RAISING THE BAR

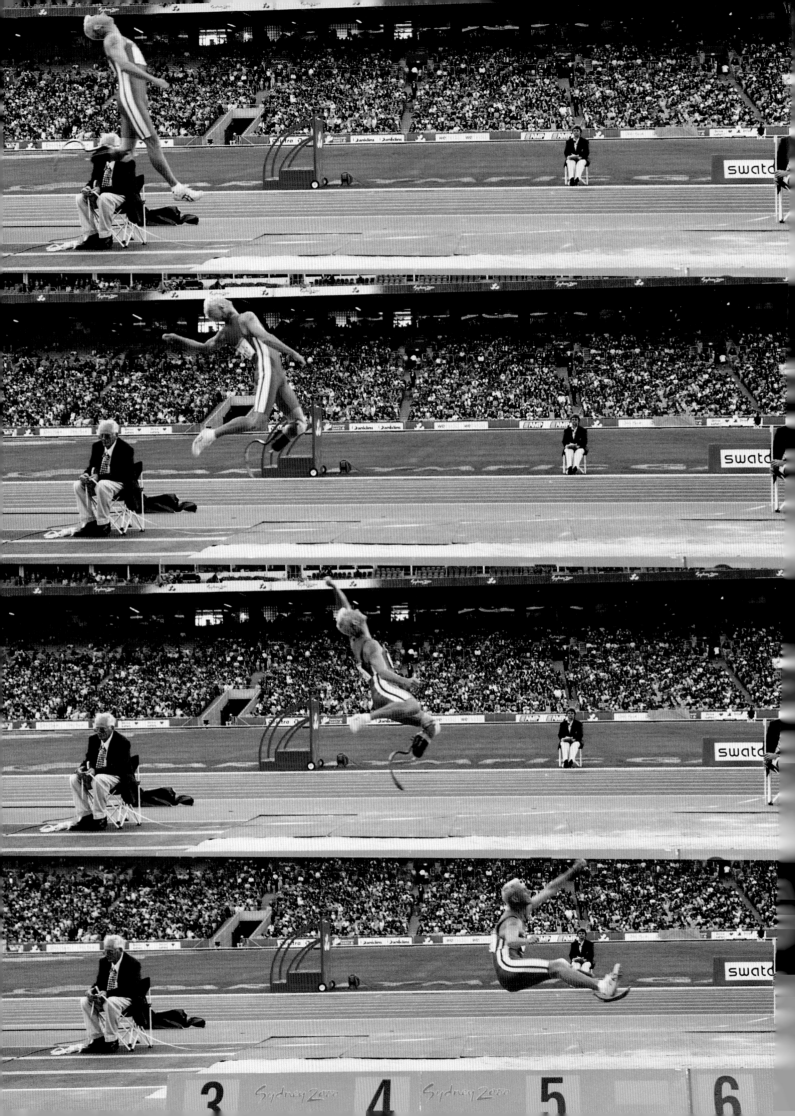

RAISING THE BAR

New Horizons in Disability Sport

ARTEMIS A. W. JOUKOWSKY III AND LARRY ROTHSTEIN / AN UMBRAGE EDITIONS BOOK

PREFACE BY CHRISTOPHER REEVE

INTRODUCTION BY PHILIP CRAVEN,
PRESIDENT OF THE INTERNATIONAL PARALYMPIC COMMITTEE

Featuring the words and portraits of athletes and
members of the international disability sports community, including
Kirk Bauer, Sarah Billmeier, Shea Cowart, Jean Driscoll,
Pam Fernandes, Béatrice Hess, Emily Jennings, Fung Ying Ki, Richard Powell,
Ann Romney, Marlon Shirley, Chris Waddell, Sara Will, and many others

IN ASSOCIATION WITH U.S. PARALYMPICS,
THE INTERNATIONAL PARALYMPIC COMMITTEE AND
DOUBLETAKE COMMUNITY SERVICE

The International
Paralympic Committee

FIRE POWER

Preface by Christopher Reeve

What a wonderful opportunity sports have been for persons with disabilities—a natural setting, an even platform, for athletes to connect, reconnect, and feel a sense of forward movement with their lives. Sports allow all of us an opportunity to excel, to show what we've got, to share our gifts with others. Sports can even push us farther, sometimes, even farther than we think we can possibly go.

Over the past fifty years we have seen a real movement develop to offer all kinds of outlets and opportunities for athletes with disabilities. Today you'll see hand cyclists circum-navigating the globe, amputee runners shattering marathon records, and disabled skiers traversing slopes next to able-bodied competitors. Technology has helped, but it hasn't been the only force behind the disabled sports movement. That has occurred—and I say this with pride and admiration—because of the individual mindset of athletes who were determined to push for greater opportunities.

Many of these athletes have made their mark in the Paralympic Games. It was only fifty years ago that those first games began. Today we see thousands and thousands of athletes worldwide train, prepare, and compete to do the very best they can in sports they absolutely love. I was in Atlanta for the opening of the Paralympic Summer Games just a year after my accident. The memory of that collection of women and men from around the world, the sight of their solidarity in spirit and mind, inspires and guides me daily.

This wonderful book provides a glimpse of this movement and some of its most inspiring leaders. Many of these men and women soon will be in Salt Lake City for the 2002 Paralympic Games, or in Athens, the site of the very first Olympic Games and now the home for the next Paralympic Games in 2004. We've come a long way indeed.

I should add, however, that the progress to provide more and more opportunities for persons with disabilities, has not only taken a leap forward because of the Paralympic movement. Simultaneously, we have seen an incredible grassroots movement to provide avenues for all persons with disabilities to have a sports outlet. One mother in Eastern Tennessee petitioned the local recreation center to make some adjustments so her son, a young man with a physical disability, can play in the local peewee baseball league. A Native American in Arizona urged his tribal council to set aside a little money so some of the young wheelchair users on his reservation could be introduced to wheelchair basketball. A young blind man set his sights on climbing the Seven Summits and, after years of training and support from family and friends, he scaled Mt. Everest. The bar continues to be raised, and the results, as we witness, benefit each of us.

Just after my accident in 1995, I received a letter from a young man in Connecticut, an athlete and a competitive runner, who was a regular participant in Special Olympics. He had just competed in a running event and had done well, winning a Silver medal for his race. He relayed to me that he had stood on the stage, received his medal, and said, "This race is for you, big dude." He sent that medal to me, sharing a moment of his glory and his pride. He added that he would be back the following year to win again, and this time, maybe a Gold! I haven't heard back from him, but given this young man's sheer grit and determination—his "fire power," as he described it—I suspect he returned, and probably won that medal, and is most likely still competing today.

Sports is a profound analogy for life. As we have discovered the benefits of the achievements we have made in sports, we can do likewise with every other aspect of our lives. As this book demonstrates, we are equal participants doing what we do best. The fire has been lit! Let us continue along that path.

Page one: U.S. Paralympian Marlon Shirley (third from left) at the start of a Gold-medal performance in the 100 Yard Dash during the 2000 Sydney Paralympic Games.
Photo by Chris Hamilton.
Page two: Franck Barré of France leaps for a Silver medal in the Long Jump during the 2000 Sydney Paralympic Games.
Photo by Benjamin Loyseau.
Right: Australian athlete Louise Savage crosses the finish line at the 2000 Sydney Paralympic Games. Photo by Chris Hamilton.

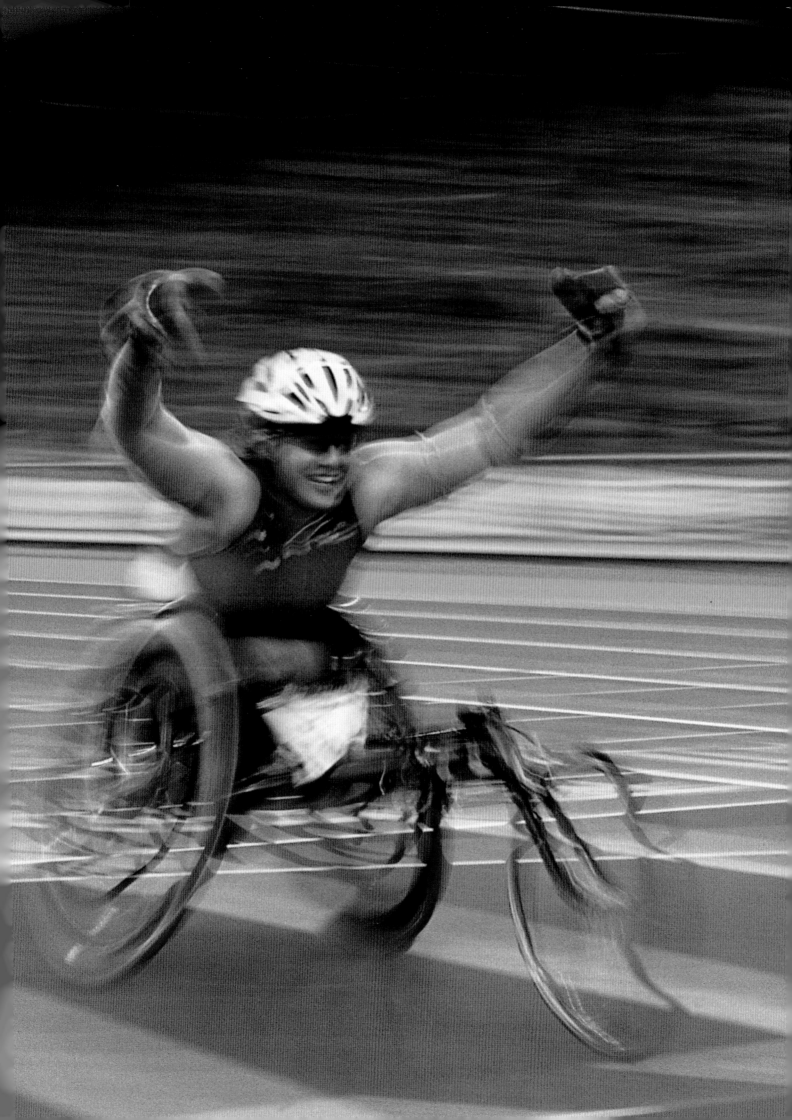

THE PARALYMPIC MOVEMENT AT THE DAWN OF A NEW ERA

Introduction by Philip Craven

President, International Paralympic Committee

Athletes at the Paralympic Games have gradually worked their way into the consciousness of the public and the media, and can now proudly claim elite status alongside their fellow Olympic athletes.

Sport for athletes with a physical disability has existed for more than 100 years. It was long ago proven that physical exercise had tremendous rehabilitation potential. While the first sports club for the deaf was founded in 1888 in Berlin, wheelchair sport experienced a dramatic increase after World War II. In 1944, Sir Ludwig Guttmann, known as the father of Paralympic sport, opened a spinal injury center at the Stoke Mandeville Hospital in Great Britain. Guttmann's new approach included sport as a vital part of his patients' total rehabilitation. Sport as a means of rehabilitation soon evolved into recreational sport and the inevitable move toward competitive sport occurred a few years later. It was in 1960 that the first Paralympic Games were held in Rome. 400 athletes from twenty-three countries competed at the five-day event.

It was Sydney 2000 that marked how far the Paralympic Games had come from rehabilitative, recreational sport to high-performance, competitive sport. The XI Paralympic Summer Games Sydney 2000 will be remembered as the best games so far in the history of the Paralympics. Across eleven days of competition, 3,824 athletes competed for 550 gold medals in eighteen sports. A record number of about 1.2 million tickets were sold, more than double the sales in Atlanta 1996. About 2,300 media representatives were on-site to cover the Games. The Games set a new precedent in webcasting, with the public being able to watch some 100 hours of Paralympic competitions on the Internet. Users across 103 countries logged on to catch the webcast. The official Games website attracted an estimated 300 million hits during Games time. It is thus not surprising that in his address at the closing ceremony, Dr. Robert Steadward, then President of the IPC, referred to the 2000 Sydney Paralympic Summer Games as "the best Games ever."

The Paralympic Winter Games, the first of which was held in 1976 in Örnsköldsvik, Sweden, is relatively new when compared with the Paralympic Summer Games. It also has a smaller competition program.

At the first Winter Paralympics there were competitions in Alpine and Nordic Skiing for amputees and visually impaired athletes, and a demonstration event in Sledge Racing. Since then, the scope of the Games has gradually increased. By and by, new disciplines like Biathlon, Ice Sledge Hockey and Wheelchair Dance Sport were added to the catalogue of Paralympic Winter sports. At the same time, more groups of athletes were admitted and the Games were thus extended not only in terms of events but also with regard to the number of athletes that took part.

At the VIII Paralympic Winter Games in Salt Lake City, from March 7 to 16, 2002, some 500 athletes compete in three sports: Alpine Skiing, Nordic Skiing and Ice Sledge Hockey. The Salt Lake Organizing Committee is the first joint organizing committee for both the Olympic and Paralympic Games.

The 2002 Salt Lake City Paralympic Winter Games come at a time of growing interest in Paralympic sport, a time of changed perceptions of the sporting achievements of Paralympic athletes. Slowly but noticeably, some IPC sports are being integrated into large international sports competitions. Since 1984, Paralympic exhibition or demonstration

events have been sanctioned by the International Olympic Committee and held during both the Olympic Summer and Winter Games, as well as at World Championships, in sports such as Athletics and Swimming, and at Commonwealth Games. At the 8th IAAF World Championships in Athletics in August 2001 in Edmonton, six Paralympic demonstration events were held, involving amputee, visually impaired and wheelchair athletes. In the women's 100m event for amputees, the double leg amputee Amy Winters of Australia won in 12.72 seconds. Such results highlight the capabilities of all Paralympic athletes. Ajibola Adeoye from Nigeria, who holds the Paralympic record of 10.72 seconds in the men's 100m event for arm amputees (class T46), is not far off Maurice Greene's world 100 meters record of 9.79 seconds.

In 1982, the International Coordinating Committee of World Sports Organizations for the Disabled (ICC) was established to govern the Paralympic Games and to represent the participating organizations in dialogue with the International Olympic Committee and other global organizations. On September 22, 1989, a new governing body—the International Paralympic Committee (IPC)—was established with its goal to create an international organization representing the democratically elected members of Paralympic sport. The IPC today includes 159 member nations, represented through their National Paralympic Committees (NPCs), and five founding sports organizations (IOSDs), which cater for specific groups of athletes, like IBSA for visually impaired athletes and ISOD for amputees. The organization, which represents people with hearing impairments, CISS, is independent from the IPC. There are a total of twenty-three sports in the Paralympic Summer and Winter programs.

For an organization as young as the IPC, with a history of only thirteen years and still run primarily on a volunteer basis, the Paralympics have come a long way. The last years marked a step forward in the cooperation between Olympic and Paralympic sport. In June 2001 the IPC signed an agreement with the IOC, which formalized already established practices and links. The agreement secures and protects the organization of the Paralympic Games, by reaffirming that the Paralympic Games will take place shortly after the Olympic Games in the same host city, using the same sporting venues and facilities.

The Paralympics must continue to expand their status and appeal to the media and international audiences. This can only be achieved through greater transparency. Spectators need to understand what is happening on the field of play. They have to understand why there is more than one 100m final in Athletics and why athletes compete in different classes. Functional classification systems are sports specific and are the subject of regular review. It would be wrong to conclude that there is a general move to reduce the numbers of classes. If this was allowed to happen, it would be at the expense of those events that actually need most protection. Functional classification ensures that the Paralympics are not only the preserve of a small selection of Paralympians but are the preserve of all our athletes.

Although the Paralympic Games have come a long way as one of the largest sporting events in the world, we must fight to uphold our core values, which are precious to the entire Paralympic Movement. Our values are based on the combination of a genuine amateur sporting ethic of fairness combined with a pursuit of elite performance. It is one of our main goals for the years to come to protect and to cultivate this identity.

RAISING THE BAR

New Horizons in Disability Sport

By Artemis A. W. Joukowsky III and Larry Rothstein

Power. Speed. Grace.
Innovative. Creative. Competitive.
Cool. Beautiful. Winner.

These are words spoken about athletes with disabilities, or "para-athletes." These words have almost never been spoken about people with disabilities in the history of the world. Until recently.

Fans jam stadiums to watch the athletes who compete. Children and adults reach out for their autographs and pictures. Millions of television viewers root them on to victory. Corporations spend enormous sums to support them. Such activities have never happened before in the history of the world. Until recently.

For thousands of years, people with disabilities were considered incapable of contributing to society. Many viewed us as burdens, good as little more than the recipients of charity; we were objects of pity, objects of fear, reminders of the fragility of life that none could escape.

Laws compounded the discrimination. Called cripples, freaks, gimps, or other names, most were excluded from jobs or locked away in attics and warehoused in institutions, where mistreatment and brutalization was endemic; still others became beggars on the streets. Literature reinforced these prejudices: Shakespeare's malevolent hunchback Richard III, Melville's vengeful, one-legged Ahab, Dickens' pathetic Tiny Tim, Tennessee Williams' lame and loveless Laura.

If you had a disability you weren't supposed to attend college, start a career, get married, or have children. You couldn't get into most buildings, drive a car, visit your friends, or easily attend a church or temple. Your most basic civil rights were in question.

But in the last sixty years, the world has changed rapidly, particularly for those living in countries that have made a concerted effort to address the needs of people with disabilities. Although much still remains to be accomplished, the courage of individuals, the persistence of organizations, alterations in the law, growing scientific and technological advances, and attitudes have helped create a new threshold of possibilities.

MY PASSION AND STRUGGLE I have been a beneficiary of such changes. I'm a venture capitalist, a husband and father of three young girls, a mentor to young people with disabilities, and a funder of scientific research into the illness that has altered my life. I have Spinal Muscular Atrophy, a disease of the anterior horn cells, which are located in the spinal cord. SMA affects the voluntary muscles for activities such as crawling, walking, head and neck control, and swallowing. Most infants with SMA die before age two, and those diagnosed with SMA after eighteen months and as late as adolescence (as I was) have difficulty walking and getting up from a sitting or bent position.

Because of SMA I fall down—a lot. I've fallen down in my house, in stores, at restaurants, in parking lots, at malls. I've fallen down in front of my children and my wife, my friends and my parents, and in front of scores of others. I fall four or five times a week. I've broken my collarbone, my ankle, my back. I've torn most of the ligaments in my legs. I've been falling since I was twelve. I'm forty now. A quarter of a century of falling.

But I always get up. Mostly by myself, sometimes with the help of my children, occasionally with the help of strangers. I get up not only because of the techniques I have learned to employ to generate balance, and the support I receive from friends and family, but because SMA has given a purpose to my life. That's its gift: to make me appreciate greatly what I have, and propel me to help find a cure for SMA and to seek opportunities to give back to others and society.

Before the onset of SMA I was an excellent athlete, even making the Hong Kong All Stars in baseball. When my family moved to New York I had visions of joining the New York Yankees, my favorite team. All that changed after my diagnosis, though I continued to participate in athletics despite my limitations. I coached baseball and football at the Browning School in New York City, and even played third-string goalie on the soccer team (I'd go in when we were safely ahead). My team was so good that we won the city championship. At college I pitched and played first baseman for an intramural softball team. Recently, I've taken up competitive ping-pong. Although lacking strength throughout my body, I still play—and even win from time to time. In addition, every week I play pick-up water basketball in a pool, three on a side.

Both games bring back to me the passion and excitement of sports—and life itself—that I felt as a child. These games test abilities and limitations, all the while pushing forward to see how far one can go.

The power of athletics to open up possibilities for people with disabilities was an insight that occurred to a Jewish refugee doctor who was assigned the job of helping British military personnel wounded in World War II. His efforts would ultimately lead to the creation of the Paralympic Games. With my friend and co-author, Larry Rothstein, we next trace the birth of disability sports and the concurrent evolution of disability rights. With these developments, new words became associated with people with disabilities: words such as hope, recovery, achievement, and rehabilitation.

FATHER OF DISABILITY SPORTS For Ludwig Guttmann, then a teenager in Germany who served as a hospital orderly, the horrors of World War I crystallized in a particular incident. One day, a man with a spinal cord injury was brought into the ward where Guttmann worked. The injured soldier was placed at the end of the ward and screens surrounded his bed to keep him from being seen by other patients. No one treated the soldier's topical infections because his doctors believed he would soon die. Within weeks, that prognosis became a reality.

A quarter of a century later, Ludwig Guttmann had become a neurosurgeon. Escaping from Nazi Germany to England in 1944 he became head of Stoke Mandeville Hospital's Spinal Injuries Unit. At that time, the hospital was crammed with British flyers and soldiers, along with servicewomen, whose spines had been cracked by the fury of battle. Accepted medical practice of that era kept spinal-cord injured patients immobile until they died, usually within five or six months. They literally rotted away from sepsis, kidney infection, and inactivity.

As Guttmann saw the enormous bedsores developing on his patients, he was haunted by the memory of the soldier who wasted away in front of him when he was a teenager. Guttmann decided that movement might be a source of relief. He had nurses turn his patients every few hours, night and day. As this continued, the sores began to disappear.

Encouraged by this breakthrough, Guttmann enlisted a quartermaster sergeant to toss a medicine ball to patients as they lay in bed, and to bat a punch ball back and forth. Gradually, the patients' arms strengthened enough so that they could lift themselves in and out of wheelchairs. With this achieved, Guttmann escalated their activity by creating wheelchair polo teams. Armed with short sticks and a disk for a puck, patients flew through an empty ward battling for victory. So fierce was the competition that Guttmann replaced polo with basketball to lessen the chance of injury. The doctor also got his patients to play darts, table tennis, snooker, skittles, and archery.

Along with the athletic competition, Guttmann had his patients engage in social activities such as the choir and plays, attend concerts, acquire skills in various trades, and take correspondence courses. With all this activity, morale soared among the patients and hope for a life after the hospital ward returned. The death rate dropped dramatically. Most miraculous of all, the vast majority of Guttmann's patients recovered.

Emboldened by these successes, Guttmann devised the first Stoke Mandeville Games for the Paralyzed. Held on the hospital's lawn on July 28, 1948, the same day as the Olympics began in London, the Games involved two teams of sixteen people, fourteen ex-servicemen and two ex-servicewomen, all competing in archery. The timing of the Games was no accident. Even then, the doctor had a vision of an international Olympics for athletes with disabilities.

A year later, five teams, including some expatriate Poles from a Polish nursing home, competed at Stoke

Mandeville. By 1950, sixty competitors on fourteen teams were in attendance, and javelin throwing was added to the program. In two years Stoke Mandeville became international, as four Dutch ex-servicemen participated. By 1954, fourteen nations were represented: Australia, Austria, Belgium, Britain, Canada, Egypt, Finland, France, Germany, Israel, Pakistan, Portugal, The Netherlands, and Yugoslavia. That same year, the International Stoke Mandeville Games Federation, or ISMGF, was created.

By the 1950s, other countries began to organize sports events for athletes with disabilities. In 1957, the French were the first to host an international sports meeting comprising various categories of people with disabilities—they had set earlier precedents with organizations such as the Comité International des Sports des Sourds (CISS), a group founded in 1924 and dedicated to organizing games for deaf athletes. Also in 1957, America had its first national wheelchair games, while Belgium, Pakistan, and Australia also held games.

In 1958, Dr. Guttmann began discussing with Dr. Antonio Maglio of Italy the possibility of staging the 1960 International Stoke Mandeville Games in Rome, the

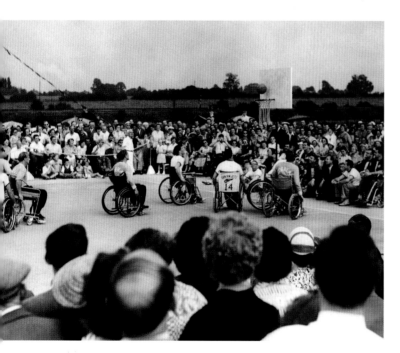

A basketball match between the USA and The Netherlands, held at the International Games for the Paralyzed, at the Spinal Injury Centre, Stoke Mandeville Hospital, Aylesbury, UK, 1955.

Olympic host city. With the support of Dr. Maglio, the World Veterans Federation, and Italian authorities, this possibility was realized immediately after the Olympics concluded.

Guttmann watched 400 para-athletes from twenty-three countries enter the Olympic Stadium to compete. Sports events included archery, basketball, swimming, fencing, javelin, shotput, club throwing, snooker, swimming, table tennis and the pentathlon. At that moment, the Paralympic Games was born, although it was not called that until 1984, and the disability sports movement was given life.

This was apparent as all the participants of the Games were given an audience with Pope John XXIII, who, looking down from a balcony in Vatican City, said to the athletes, "You are the living demonstration of the marvels of the virtue of energy. ... You have shown what an energetic soul can achieve, in spite of apparently insurmountable obstacles imposed by the body."

THE DISABILITY MOVEMENT The shift from hopelessness to rehabilitation and athletic potential that Dr. Ludwig Guttmann set in motion, along with the help of many others around the world, was virtually unthinkable before the twentieth century. Throughout most of history, families were the first line of care for people with disabilities. If family members would not or could not support them, people with disabilities frequently resorted to becoming paupers and begging for alms. Without an income, they often faced being housed in state-funded institutions.

Over time, institutions were established in Europe and America for specific categories of disability such as the deaf, the blind, and the "feeble-minded and retarded." In many cases, these institutions became chambers of horror rather than places of care. In Africa, Asia, the Middle East, Latin America, and the Caribbean, families continued to hide their members with disabilities because funds were not available to build large institutions.

After World War I, governments in Europe and America started to provide rehabilitation services to returning veterans who had suffered war injuries, and benefits to those victimized from industrial-related accidents. These were considered the "worthy" disabled. With the rise of the welfare state in the 1930s, government-funded benefits and entitlement programs were established for people with disabilities.

By the late 1940s and early 1950s, scientific advances began to increase the number of people surviving accidents, injuries, and diseases such as polio. Primarily American organizations such as the National Spinal Cord Injury Foundation, the Muscular Dystrophy Association, the Easter Seal Society, the National Association of Retarded Citizens and the United

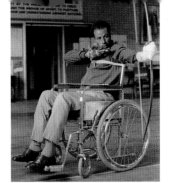

Former marathon runner and winner of two Olympic Gold Medals, Abebe Bikila practices archery from his wheelchair in preparation for the International Games for the Paralyzed, Aylesbury, UK, 1970.

Cerebral Palsy grew in number, size, and importance. They were mostly run by non-disabled people, often parents and relatives of people with disabilities, and by professionals. A chief source of revenue for such organizations was the telethon, a mixture of entertainment and "sob stories" about people and children with disabilities.

Ultimately, international organizations such as the World Federation of the Deaf (WFD), and the International Federation of the Blind (later the World Blind Union) were formed, composed of national, non-profit organizations interested in the prevention of disability and the integration of people with disabilities into society. All of these international organizations were "uni-disability," i.e. focused on a single disability. In 1953, the Council of World Organizations Interested in the Handicapped, an umbrella organization of many of these international uni-disability organizations, was established.

By the end of the 1950s, the United States and a number of other countries were moving from almost total indifference to people with disabilities to ensuring a minimal level of care. Most still believed that people with disabilities would, in the great majority of cases, always require segregated care and protection. All that would change in the 1960s, as people with disabilities in America joined the poor, African Americans, and women struggling to achieve equality and civil rights. In 1962, a post-polio quadriplegic named Ed Roberts, after some difficulty, became the first person with disabilities to be admitted to the University of California at Berkeley. Since no dormitory was accessible and Ed required an iron lung at night, he was forced to live in the student infirmary. Over the next several years, other students with disabilities were admitted to Berkeley. By 1967, twelve students with disabilities were living in the infirmary. They began to call themselves the Rolling Quads.

In the late sixties, the Rolling Quads, weary of the infirmary and of depending on others for help, decided to live on their own. With federal funds, they established the Physically Disabled Students Program (PDSP). Created by people with disabilities and designed to serve their needs as they saw them, PDSP became a model for how people with disabilities should live independently. PDSP favored innovative self-help and group organizing. It wanted the means—equipment, transportation, housing, health care—that would ensure integration into society according to an individual's ambition, abilities, and potential.

This program led to the Independent Living Centers that exist around America today. Also out of PDSP came the beginnings of a revolution in self-perception among people with disabilities. They took pride in their disabilities and celebrated it as a difference among people. New words were now associated with people with disabilities, words such as independence, self-help, dignity, and full participation.

FROM REHABILITATION TO ELITE SPORTS

Although the international scope of Paralympic Games grew between 1960 and 1980, its founders still saw the Games as functioning within a medical model, with rehabilitation as its primary goal. Guttmann's approach and that of the ISMGF (later the International Stoke Mandeville Wheelchair Sports Federation, or ISMWSF) clashed with some American, European, and Asian disabilities organizations that wanted the Games to serve the needs of elite athletes. While the ISMWGF limited participants to those with spinal injuries, other organizations welcomed competitors with any type of lower body impairment. Guttmann maintained that competition should occur between those with similar disabilities. Others argued that competition should take place between those who could do that sport equally well, no matter the type of disability.

One person who felt that competition should occur between athletes with a range of disabilities, Andre Raes, organized the European Wheelchair Basketball Championship. Ultimately, Dr. Guttmann invited Raes to join him, and in 1972, Raes became the chairman of the Wheelchair Section of the ISMGF. This led to the establishment in 1973 of the Gold Cup Wheelchair Basketball World Championships. In Asia, the first wheelchair races at the International Games for the Disabled in Tokyo were held in 1964. The Winter Paralympic Games held in 1976 allowed blind and amputee athletes to participate, becoming the first ever to include disabilities other than spinal cord. Later that year, in the Summer Paralympic Games, blind, amputee, and cerebral palsy athletes competed.

By the early 1980s, the recognition that organizational issues among different disabled sport organizations existed led to the creation of the International Coordinating Committee of World Sports

Organizations for the Disabled (ICC) in 1983. While the ICC was a huge step forward, it had its problems. Members were appointed, not elected, and there was no national representation in the organization. The sport federations still refused to allow their athletes to participate in each others' events.

In 1984, the Summer Games split due to problems with funding and organization. Two Games were held: one at Stoke Mandeville for the Paralyzed, and one at New York for amputees, the blind, and those with cerebral palsy. Yet by 1987, the unified Games was reconstituted, understanding the need for unity. Representatives voted to change the structure of the ICC to include not only representation from the sport federations, but also representation from regional athletes.

It was not until the 1988 Seoul Paralympic Games that the proper organization and the shift from sport as rehabilitation and recreation to elite sport were demonstrated. The 1988 Games are commonly considered the first games of the modern Paralympic era.

SEOUL At the 1988 Seoul Paralympic Games, para-athletes played in front of stadiums filled with 20,000 people; 100,000 people attended the Opening Ceremonies. Athletes were housed in a specially constructed village designed to be used after the games by individuals with disabilities. Official transport was efficient and prompt. The Opening Ceremonies were spectacular: skydivers, jets flying past, thousands of children, a T'aekwondo demonstration, stunning Korean dances, and 700 wheelchair dancers.

Ljiljana Ljubisic, a double medalist in Discus and Javelin, recalls her feelings, "In Korea we went another step higher. We were in the same city, in the same country as the Olympics. We had a Paralympic Village. That was a huge step in our identity and our ability to raise money in order to do what we needed to do." In all, 971 new World Records were set. Trischa Zorn of the United States starred, winning twelve Gold medals

in Swimming and setting nine World Records.

The advance in the individual games themselves was paralleled in the growing complexity of their organization by the late 1980s. The International Paralympic Committee (IPC) was founded on September 21, 1989, in Dusseldorf, Germany by six international organizations representing sports for people with disabilities. The assembly voted unanimously that the International Paralympic Committee would be the sole world governing body for athletes with disabilities. The IPC organizes all World Championships, the Paralympic trials, and the Paralympic Games.

INTERNATIONAL DEVELOPMENTS Paralleling the development of an international sports community in the years 1960–80 was the development of international organizations for people with disabilities. In Africa, where more than 50 million people had disabilities, self-help groups formed to work for changes in society. These were both uni-disability and multi-disability groups. These organizations received little or no governmental help; instead they relied on non-governmental development aid agencies from the West. Countries such as Mauritania and Zimbabwe benefited from such funding. Ultimately, a regional coalition was forged with the help of Goodwill Industries of America called the West African Federation for the Advancement of Handicapped Persons (WAFAH).

In the Asian/Pacific region, which includes the Middle East, South Asia, Southeast Asia, and the Far East, where more than 250 million people have disabilities, the picture during these years was not as bright as in Africa. According to the World Health Organization, only two percent of people with disabilities received any kind of services. Many religions, such as Shinto and Buddhism, viewed people with disabilities as a curse on the family. As a result, many were hidden away. At this time, there were few self-help organizations. A number of Asian countries, such as Singapore and Pakistan, had blind organizations associated with the International Federation of the Blind. Thailand had an organization for the deaf, and Fiji had organization for paraplegics, among other groups. In Japan there were many local and small self-help groups but they were not unified nationally. These are only a few such groups which began to organize internationally.

In Latin America, more than 34 million people lived with disabilities. Most of these were the poorest of the poor. Many organizations for people with disabili-

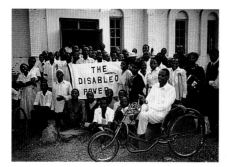

From the African Development Foundation's publication: Sustainable Development and Persons with Diabilities: The Process of Self-Empowerment. Photograph by Thad Kaminski.

ties were based on Christian beliefs. These organizations, called Christian "Fraternities," included people with all kinds of disabilities, and people with disabilities are in the majority on their boards. Brazil, where the movement started in 1942, had 200 small groups in different regions of the country by 1985. In the late 1970s, secular organizations for people with disabilities had been formed in Argentina, Costa Rica, Cuba, El Salvador, and Nicaragua for mutual support and for civil action. Such efforts for reform culminated in the United States in 1990 with the passage of the most significant civil rights legislation since the mid-1960s.

POLITICAL FORCE It was a warm, bright day on July 26, 1990 when more than 3,000 people—a record number—crowded the White House lawn to witness President George Bush sign into law the Americans with Disabilities Act (ADA). As the President passed out the pens he was using for his signature, he turned and handed one to Rev. Harold Wilke of Claremont, California, a leader in the disability community and the clergyman who had given that day's benediction. The reverend, who did not have arms, reached out with his stockinged left foot and gracefully accepted the pen.

The ADA allowed people with disabilities for the first time to enjoy the same civil protections as their fellow citizens. People with disabilities could now compete in the marketplace, be considered for jobs based on ability, use private and public transportation, and be allowed to enter buildings without concern for barriers.

The need for comprehensive legislation was clear. But there was substantial opposition to ADA. Business groups feared that the cost of compliance and potential litigation might bankrupt many companies. State and local governments worried about tax increases necessary to carry out the law. To counter these concerns, disability groups and related organizations developed a united voice to support the legislation. A bi partisan coalition, aided by President Bush's support, pushed the bill through Congress.

Although compliance still remains an issue a decade later, and some areas remain unaddressed— unemployment among people with disabilities remains near seventy percent—the ADA was a landmark in the struggle for all people to enjoy the full fruits of freedom. Under current President George W. Bush, efforts are underway to significantly increase funding for the ADA and to extend the range of the act.

On the international level, people with disabilities began to be dissatisfied with the organizations that represented their needs and the slow progress in addressing them that was being made in many nations around the world. The result was the establishment of Disabled Person's International (DPI). By the mid-1980s, there were disabled peoples' organizations, either uni-disability or multi-disability, in virtually every country in the world. The founding of DPI served to provide organizations with an international voice and an impetus to consolidate into national multi-disability coalitions where none had existed previously.

DPI pushed four key issues in its presentations to international forums. First, DPI established definitions for the drafting of international documents and in meetings on disability. DPI rejected a medical definition and proposed

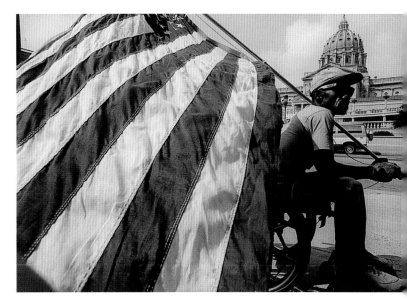

that physical and social environments excluded people with disabilities from participation.

Second, DPI was concerned that the United Nations and governments worldwide should recognize that people with disabilities were the best judge of their own needs and concerns. Third, DPI wanted consultative status for itself with the UN and other governmental agencies that served people with disabilities. This was achieved. Finally, DPI sought to increase international peace prospects, since war was a prime cause of disability.

A member of American Disabled for Accessible Public Transportation (ADAPT) protests inadequate funding for home care services that allow individuals with disabilities to remain at home rather than being sent to nursing homes. Photograph by Harvey Finkle.

By the 1990s, the vocabulary of people with disabilities throughout the world was augmented to include words like citizen, participant, litigant, and political force.

A SPARK OF FIRE "The atmosphere in Barcelona was absolutely wonderful," recalls Dr. Robert Steadward, president of the International Paralympic Committee. "There were line-ups outside the venues for hours and hours to get the best seats in the houses. People who did get seats were thrilled by what they saw, and they saw greatness. An astounding number of records were broken. Adults as well as children asked for the autograph or picture of the para-athletes."

The opening ceremonies at Barcelona in 1992 were a marvel of art and organization, from the Picasso-inspired masks given to spectators to the flamenco dancers and horsemen. Extensive daily television coverage ensured that all of Spain and much of Europe shared in the excitement. Stephen Hawkins, the great physicist who has amyotropic lateral sclerosis (ALS), spoke to the crowd saying, "Each one has within us the spark of fire, a creative touch." As his words echoed in the vast stadium, an archer shot a flaming arrow to the top of the cauldron and lit the Paralympic torch.

Seoul had inspired athletes, coaches, and sports manufacturers to new heights. These advances led to wonderful performances in Barcelona. Ajibola Adeoye of Nigeria, a single-arm amputee, ran for the Gold in record time. Tony Volpentest, using two prostheses, ran 100 meters in 11.63 seconds—only 1.77 seconds slower than Olympic runner Carl Lewis' best time of 9.86. Trischa Zorn of the USA shone again, winning ten Gold Medals in Swimming. Her teammate, John Morgan, won eight Gold and two Silver.

The urban renewal of Barcelona for the Games resulted in the building of one thousand specially designed apartments that were barrier free and that incorporated many features for ease of use by those with disabilities.

Ljiljana Ljubisic, veteran of six Paralympic Games, recalls, "When it came to performance, we were equivalent to the Olympics. It was the first time that we were treated 100 percent fully like the athletes that we are and respected as the human beings that we are, and there was no difference in attitude, or facility, or access to facility and programs."

The following Paralympic games continued to catch the spark of fire from Barcelona. The Atlanta Games in 1996 drew more than 3,100 athletes from 103 countries, including for the first time athletes with a mental handicap. Nearly 270 World Records were set. Also in Atlanta, worldwide and national sponsors used the Paralympics for the first time as an investment opportunity rather than a charitable deduction. More than sixty companies supported the Games including Coca Cola, IBM, Motorola, Turner Broadcasting, Kodak, Swatch, Home Depot, Sunrise, Bell South, and Naya Spring Water.

The Games in Sydney, Australia in 2000 were even bigger. More than 4,000 athletes from 125 countries participated. To add to this historic moment, Robert Steadward, president of the International Paralympic Committee, became a member of the International Olympic Committee. As Steadward says, "Our two movements now have a much closer relationship and we're prepared to work together for the betterment of all people in the world, and all athletes."

W INTER GAMES While the Summer Games have become huge events, the Winter Games remain small, intimate affairs with a family atmosphere. Most of the participants know one another well, and the logistics for the organizing committee are much less complicated.

Because the Winter Paralympics were started by people with a sport, rather than medical, background, they have always operated according to an athlete's physical ability to do the sport, rather than on his or her medical diagnosis. Winter sports for people with disabilities present obvious problems of transport and equipment, which are aggravated by cold, ice, and snow. But these games doubled in size between 1976 and 1994: While Sweden hosted fifteen countries in 1976, Norway hosted thirty-one in 1994. The 2002 Salt Lake City Paralympic Games expect over thirty-five to participate.

Dr. Gudrun Doll-Tepper, a disabled sport scientist, sees the Games at Lillehammer in 1994 as a milestone because of the tremendous support from the people of Norway and the degree of enthusiasm and introduction of new sports. She says, "I remember so well the first time I saw an ice sledge hockey game. People were really shouting; they were so excited to see such a new game. It opened doors to those who are only interested in sport in general but not so much in disability sport." The king and queen of Norway were in attendance almost daily. Media coverage was unprecedented, with seventeen countries vying for footage on a daily basis.

THE SPREAD OF PARA-ATHLETICS Just as the last several decades have seen the rapid advances in elite sports, the same time has also seen an explosion in sporting activities at all levels of competition. Mountain biking, kayaking, scuba diving, water skiing, skiing, motorcycling, fencing, tennis, football, bass fishing, martial arts, handcycling, softball, weightlifting, trapshooting, and rugby are just some of the sports engaged in by people with disabilities.

Recent years have seen the rise of numerous organizations that provide the structure for these sports. In America, the National Sports Center for the Disabled (NSCD), which began in 1970 as a one-time ski lesson for twenty-three amputee children, has evolved into the largest and most successful program of its kind in the world. In addition to recreational downhill and cross-country skiing, snowboarding, and snowshoeing lessons, NSCD provides year-round competition training to ski racers with disabilities. Summer recreation opportunities include biking, hiking, in-line skating, sailing, horseback riding, white water rafting, baseball, fishing, rock climbing for the blind, and camping. Also in the U.S., Disabled Sports USA, a national, nonprofit organization, was established in 1967 by Vietnam veterans with disabilities. It serves the war injured and offers nation-wide sports rehabilitation programs to anyone with a permanent physical disability through a network of community-based chapters. Each chapter sets its own agenda and activities. Activities include water skiing, water sports, sailing, cycling, horseback riding, golf, and summer and winter competitions.

But people with disabilities have brought a new perspective to the use of sports, as they have in many of the activities they engage in. A team of Vietnamese and American ex-POWs

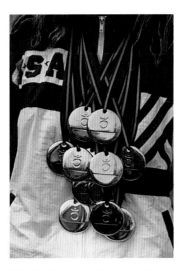

Trischa Zorn, visually impaired as a result of a congential eye condition, is considered one of the "winningest" athletes in the history of the Paralympic Games. She has won a total of fifty-four medals over the past twenty years. Here she proudly displays her medals from the 1992 Barcelona Paralympic Games. Photograph by William R. Sallaz.

Vietnam War veteran, Dan Jensen, shares a moment with the curator of the Tomb of the Unkown Soldier in Vietnam, a moment captured during World T.E.A.M. Sports' Vietnam Challenge which took place in January 1998. An Emmy Award-winning documentary Vietnam, Long Time Coming captures the 1200-mile bicycle journey from Hanoi to Ho Chi Minh City. Photo Courtesy World T.E.A.M. Sports.

and former enemies, disabled and able, undertook a sixteen-day bicycle journey that began in Hanoi and concluded in Ho Chi Minh City. Their route took them through rice paddies, villages, and jungle terrain that once were war zones. The event served to bond the teammates, helping them reconcile the impact of that not-so long-ago conflict.

The *Vietnam Challenge* was the work of World T.E.A.M. (The Exceptional Athlete Matters) Sports, a not-for-profit organization which brings together able-bodied and para-athletes in events that seek to deal with some of the world's most difficult problems. World T.E.A.M. Sports was founded to provide greater access and opportunities in sports for all people, especially persons with disabilities. Every three or four years, it plans and executes an adventurous, global challenge event, which dramatically demonstrates the organization's basic tenet that we are all on the earth together and that, "we all ride the same road."

In the autumn of 2002, just a year after the tragic events of September 11, World T.E.A.M. Sports will complete a route of some 250 miles, on bicycles and handcycles, beginning at Ground Zero in New York City and concluding in Washington D.C. This large, single team, including over 3,000 cyclists, one for each individual who lost their lives, will be a powerful symbol of solidarity and unity—again, using sports as a means to show how disparate groups of people and nations can come together. This three-day event will include family members, survivors, firefighters, and police personnel from New York City and the Pentagon, as well as a team of international athletes. This event will demonstrate the power of sports to bridge and build communities and provide a model for people all over the world to emulate as we seek to understand and reconcile deep and profound differences across physical, national, religious, and

cultural borders. World T.E.A.M. Sports is just one of many organizations dedicated to integrating athletes from across a wide range of viewpoints and abilities, encouraging them to work together.

ASSISTED TECHNOLOGIES For the writer John Hockenberry, paralyzed from an auto accident, people with disabilities not only have a new role in dealing with international issues such as peace, but they also can be the leaders of a broader societal trend toward the use of assistive, or adaptive, technology. As he writes, "With the advent of miniature wireless tech, electronic gadgets have stepped up their invasion of the body, and our concept of what it means and even looks like to be a human is wide open to debate. Humanity's specs are back on the drawing board ... and the disabled have a serious advantage in this conversation. They've been using technology in collaborative, intimate ways for years—to move, to communicate, to interact with the world."

Technological breakthroughs have come about in recent years that may foretell the possibility of what was once the realm of science fiction—"bionic" men and women. But at the moment, there have been significant advances in wheelchair design, orthotics, and prosthetics. In part, these breakthroughs came about because of the demands by athletes with disabilities for improved performance in elite competition, as well as by athletes with disabilities for recreational sports.

Early disability sport competitions featured wheelchairs weighing fifty pounds and constructed largely for the needs of attendants who would be pushing them. Para-athletes often took hacksaws to modify the chairs so that they would perform better in competition. As the competitions intensified, para-athletes overturned many of the rules that restricted the development of new design features. Now, wheelchairs weigh as little as fifteen pounds, have three wheels, and are as sleek and colorful as the uniforms worn by the competitors.

The same drive for improved performance has resulted in a spectacular leap forward in prosthetics. For generations, legs were carved from wood by skilled craftsmen, so-called "limb makers." Braces were made from forged steel. All of this has changed. Computer-generated images enable designers to create overnight a mold that almost exactly works with the athlete's body. New materials such as titanium and graphite allow increased flexibility and maneuverability, resulting in racing times that are nearly as fast as able-bodied athletes.

The new wave in prosthetics utilizes microprocessor embedded chips, paired with sophisticated sensors, to radically increase functionality. The immediate challenge is to create an artificial leg that can manage balance, stability, and comfort on its own. At MIT's Leg Laboratory, a new class of digitally controlled "smart" legs are allowing more freedom and confidence.

Another is the C-Leg, made by Otto Bock, a German company. With the C-Leg, amputees can finally walk without thinking about how to walk. This innovative knee joint features on-board sensor technology that reads and adapts to the individual's every move. By using special software and a PC, fine adjustments can be made to tailor the C-Leg to the amputee. Angles and moments are measured fifty times per second, ensuring that the dynamic gait is as similar to natural walking as possible.

Other colleges have joined the quest for improved products. At Hampshire College's Lemelson Assistive Technology Development Center students work on innovative adapted technologies. Among the many new devices the center has created is the Accessible Snowboard. This allows riders to strap themselves in, either sitting or kneeling. Boarders are low to the ground for better balance and can right themselves after a wipeout using upper-body strength. The board also has a lever that raises or lowers the seat to the right height for chairlifts.

For Hockenberry and the scientists and students who are laboring to devise adopted technologies, their work represents, ultimately, a new definition of human, which includes a whole range of biological-machine hybrids, of which people with disabilities are only one example. The organic merging of machine, body, and mind may well signal another level of human existence.

WORDS AND MEANING Surprisingly, our most reliable guide to mastering our future may be the humble words we speak. Words are normally used to describe the world. But more precisely, they generate a world. For thousands of years the words that were used to describe people with disabilities generated a world of limitations, horror, anger, fear, and shame. Over the last sixty years, a host of new words have helped generate a new reality for people with disabilities. Now these words lead to opportunity, innovation, hope, excitement, and participation.

However, much remains to be done. Most sobering

is this reality—more than 500 million people around the world have disabilities, more than 80 percent of whom live in the developing world of Africa, Asia, the Middle East, Latin America, and the Caribbean. In some countries the instance of disability due to malnutrition and communicable disease is estimated at 20 percent of the population. In the last twenty years, Disabled People International, the United Nations, and other world organizations have emerged as international organizations that are trying to deal with the problems of people with disabilities. They, like their compatriots in the United States and Europe, have been striving to extend civil rights and ensure full participation in their societies.

The Paralympians, like their Olympic counterparts and all the people with disabilities who participate in sports at any competitive level, are playing a vital role in providing inspiration and role models for what the world can look like if all are given a chance to fulfill their hopes and dreams.

An example shows the power of this idea:

By all accounts, Bonnie St. John Deane has it all. At just thirty-six, she has attended Harvard, earned a Rhodes scholarship, been an award-winning IBM saleswoman and a White House policy advisor, started her own business, gotten married, and has a six-year-old daughter. She also has won a Silver Paralympic medal as a skier.

Bonnie's life has been a set of challenges that she has dealt with using courage and creativity. Born with a right leg markedly shorter than her left, Bonnie wore a heavy brace and orthopedic shoes as a child. At age five, doctors told Bonnie that they would have to amputate the shorter leg. After the surgery, she found herself ostracized by her peers. "I was called 'wooden leg' and excluded from games," she says. By the second grade, Bonnie was convinced that she was ugly and undesirable. At lunch time, she sat in a playground corner and read books. She lived more and more in her imagination, where she was able to "go anywhere and be anything I wanted to be."

Bonnie's mother, a San Diego school vice principal, helped Bonnie stay positive. Together they read inspirational books, wrote affirmations, and attended motivational speeches. "I began giving myself inner pep talks," Bonnie says. Rather than focusing on her isolation, Bonnie turned to excelling at her studies. She pushed her physical limits, taking up water skiing and horseback riding. As she did, her confidence soared.

Then a friend invited her to ski at Mammoth.

Bonnie plunged into insecurity and fear. How could an amputee ski? To answer this question, she called organizations for people with disabilities. She read books on amputee skiing. She investigated the problems she'd encounter—getting on and off chair lifts, standing, and falling. Finally, Bonnie decided to go.

The trip turned out to be life-changing, but only because Bonnie persevered. During the first day, she fell constantly. Then, when she could finally stand up, she faced another obstacle. As an amputee, she couldn't snowplow, which made slowing down and stopping very difficult. The better she got the harder she crashed. As she had learned to do, Bonnie focused on the positive. On skis she felt as if she were flying: "I could be graceful and go fast for the first time in my life."

By her fifth day, she was tackling intermediate slopes. She decided to train for racing. She was accepted into an elite Vermont ski school, but she fractured her left leg in a skateboard accident, and six weeks later broke her artificial leg. Each time Bonnie felt like giving up, she reminded herself that she had the power and the support to achieve her goals.

She went on to win six medals in a national competition and qualified for the 1984 Innsbruck, Austria Paralympic Games. She was in first place after her initial slalom run, but fell on an ice slick during the second run. She jumped back up and finished the race. She won two Bronze medals for Slalom Racing and finished seventh in the Downhill. Her overall performance earned her a Silver medal. Bonnie realized something: "Winners aren't people who never make mistakes. Winners are those who get up and finish. Gold-medal winners get up the fastest."

In the world that Bonnie grew up in, competing in the Paralympics, attending college, starting a career, or getting married and having children were all remote possibilities. Now, thanks to people like Ludwig Guttmann, entities like Independent Living Centers, laws like the ADA, and supportive friends and relatives, Bonnie, as well as millions of others, can live in a world where the words that generate their reality include: citizen, participant, achiever, innovator, champion, human being.

These words are empowering and challenging to us all. In *Raising the Bar*, we have gathered together the voices and images of athletes from around the world who have taken up this challenge in ways both big and small. With it, we aim to celebrate and to challenge each one of us to live our lives, with grace, to its fullest potential: faster, further, stronger—together.

mind

SHEA COWART (United States)

Highlights: 2nd place 100m and 2nd place 200m at the 1999 Disabled Sports USA (DS/USA) National Summer Games, Fairfax, VA; World Record in 100m at the 1999 Pan Am Games, Mexico City; 1st place 100m and 1st place 200m at the 2000 Paralympic Trials in New London, CT; 1st place 100m at the 2000 Olympic Trials Demonstration Event in Sacramento, CA; Gold medal 100m, World Record and Gold in the 200m at the 2000 Sydney Paralympics; Broke World Records in 100m, 200m, 400m at the 2001 International Challenge, San Diego, CA; YWCA Board Member; Member of Disabled Sports USA and the Atlanta Track Club

Event(s): Track and Field

Photo by Jamie Sanchez

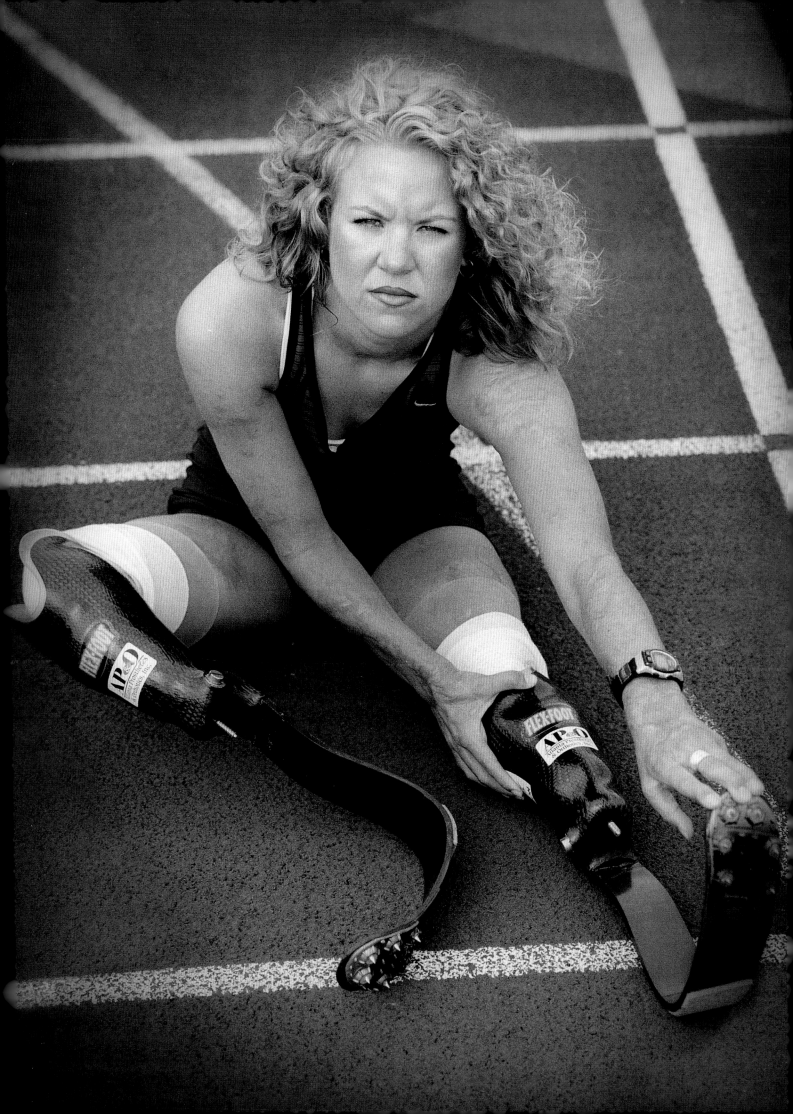

body

CHRIS WADDELL (United States)

Highlights: 4 Gold medals in Alpine Skiing at the 1994 Lillehammer Winter Paralympic Games; Gold and Silver in Slalom at the 1998 Nagano Paralympic Games; Gold and Bronze in Wheelchair Track events at the 1998 International Paralympic Committee World Athletic Championship, Birmingham, England; Silver in the 200m at the 2000 Sydney Paralympic Games

Event(s): Alpine Skiing, Slalom, Wheelchair Racing

Photo by Jamie Sanchez

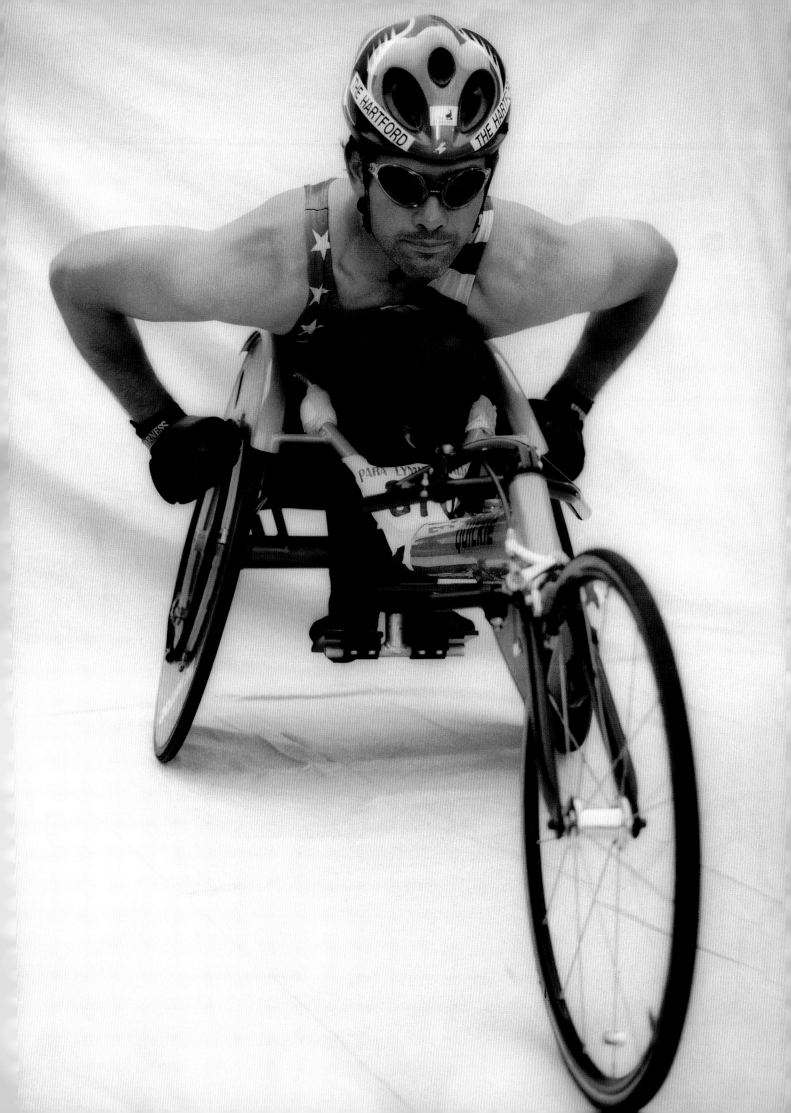

spirit

TIM WILLIS (United States)

Highlights: Georgia Blind Person of the Year award, 1992; Georgia Sports Hall of Fame Achievement Award, 1995; Semi-finalist for the Sullivan Award as the top US amateur athlete, 1996; Silver medal, 10,000m and Bronze in the 1,500, 1,600, and 5,000m relays, 1996 Atlanta Paralympic Games; Bronze in 10,000m at the 2000 Sydney Paralympic Games; 2 World Records in the 10,000m, Silver in the 5,000 and 10,000m at the 1998 World Championships, Madrid, Spain. Graduate of Georgia Southern University and of Mercer University Law School.

Event(s): Distance Running

Photo by Jamie Sanchez

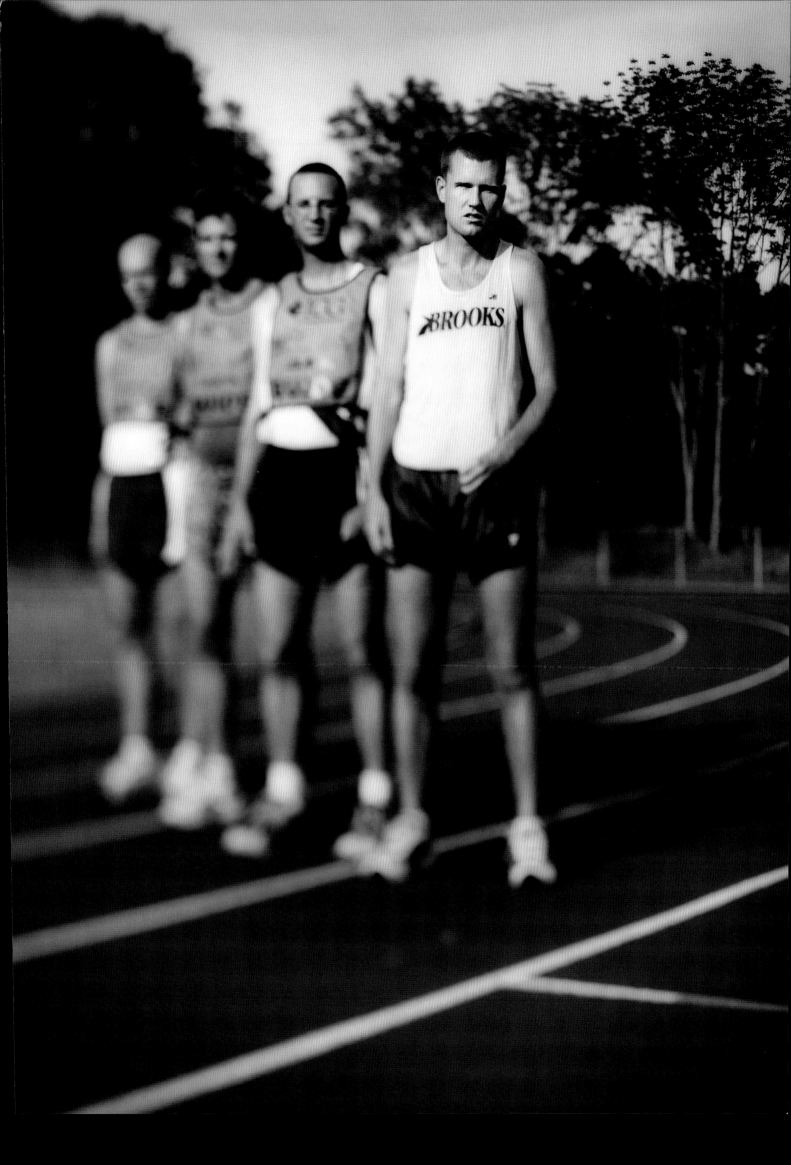

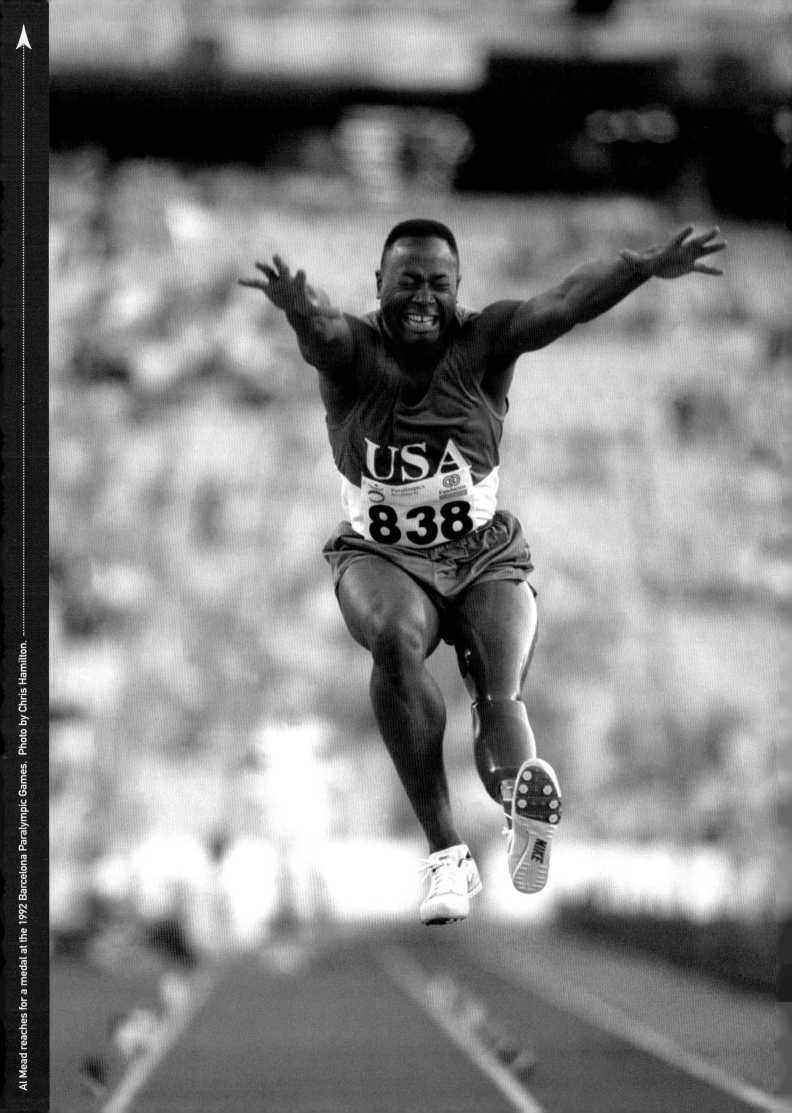

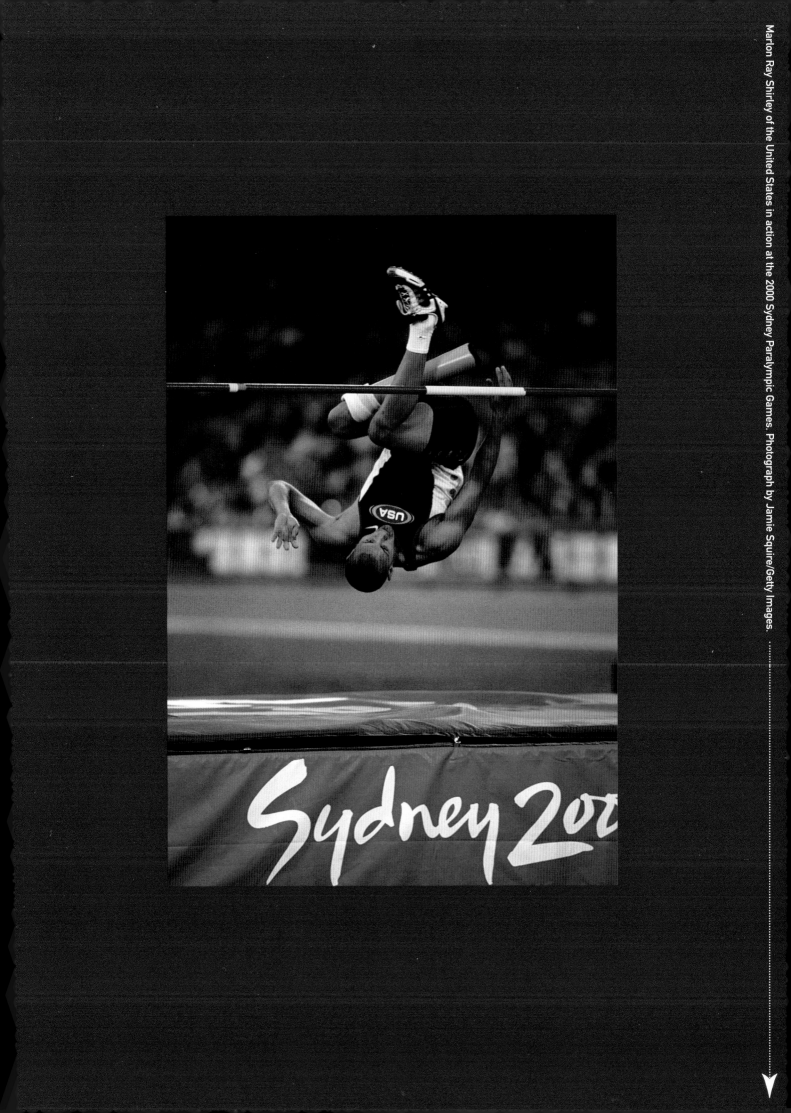

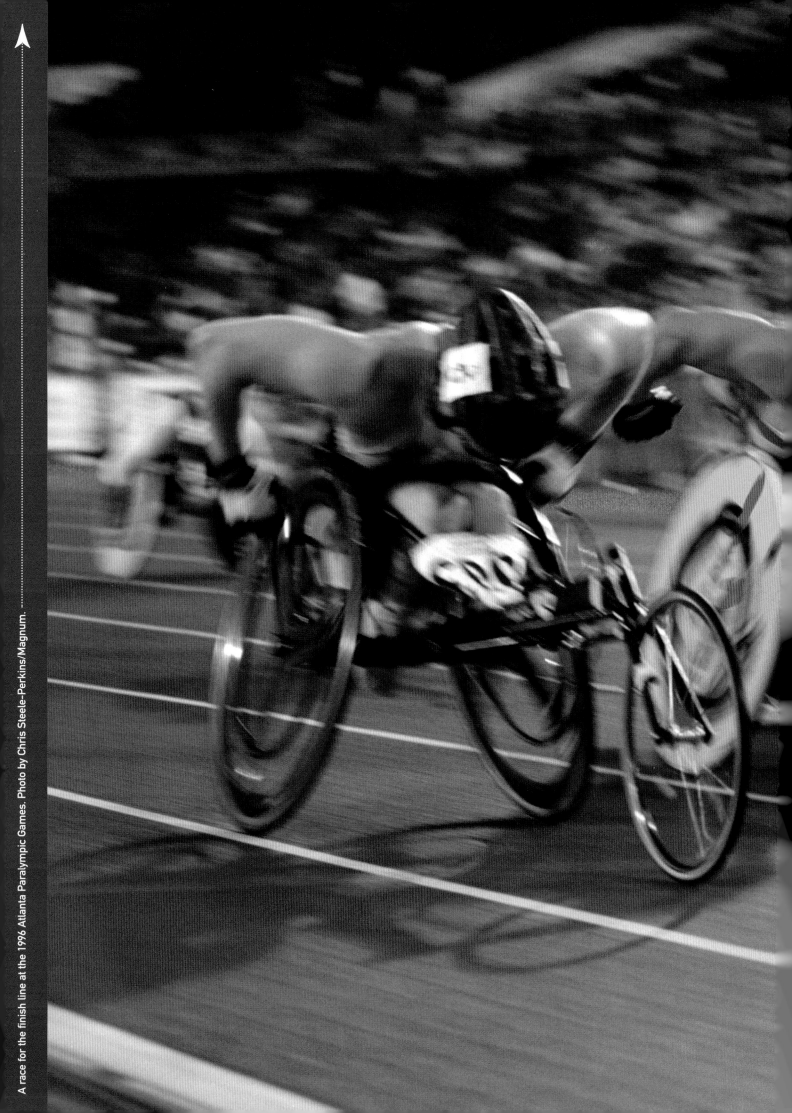

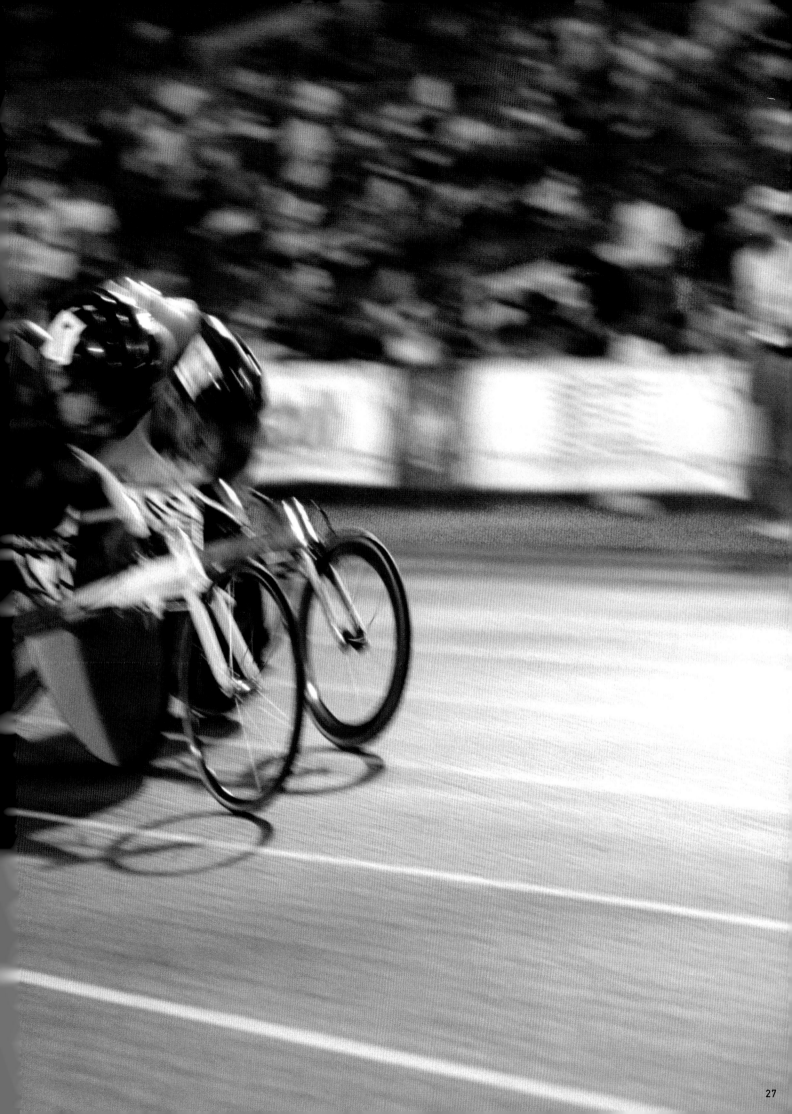

"

When I discovered wheelchair sports, my world seemed to open up. Suddenly, I was able to "get in there and get dirty" along with the other kids. I started out playing wheelchair soccer, but eventually got involved in football, ice hockey, tennis, softball and several other sports as well. ... I've now been a member of two U.S. Olympic Teams and four U.S. Paralympic Teams. I also own the World Record in the 10,000-meter event on the track and hold World Best times in the 10K and marathon distances on the road. Athletic participation and competition has changed my life. I am fit, strong, confident, and well-traveled. I have a public platform on which to encourage others through speaking, as well as to educate people about what disability is and isn't.

Sport is a tremendous vehicle for education. In the athletic arena, disability is seen as a characteristic like hair color or shoe size, rather than a defining principle. When sports events are integrated, the focus turns from the person with a disability to the guy with a great shot or the gal with a fast 800-meter time. Integration provides the perfect venue where "actions speak louder than words."

Courage is defined by Webster as the ability to face danger without fear. I don't think I've done that more than once or twice in my life. Although I've been described as courageous by many who have seen me racing or sitting in my wheel-

chair, the label doesn't fit. If you change the word "danger" in Webster's definition and replace it with "difficult situations," however, then I can talk about courage in my life. It's something I've had to develop over the years. I have a shy side to my personality and it took a while for me to accept the position as a role model and spokesperson once I started winning big races and breaking records consistently. I didn't want the responsibility of being an example for others to watch and follow. Now, I embrace that role, but it took courage in the early years to accept the platform I was being given. It took courage to stand out among the others. I have found that few people allow themselves to stand out among others because it's not always a comfortable place to be. The spotlight is bright and it can be hot, too. I have a high amount of respect for people who have developed the ability and courage to step out and be recognized, whether or not it's the popular thing to do.

JEAN DRISCOLL (United States)

Highlights: Gold, Silver, and 2 Bronze medals, 1988 Seoul Paralympic Games; Broke World Record 1990-94, holds current World and Course Record; 1 Gold, 1992 Barcelona Paralympic Games; 2 Gold, 1 Silver, 1 Bronze, and World Record in 10,000m, 1996 Atlanta Paralympic Games; 1997 Gene Autry Award recipient; Boston Marathon—winner, 1990-96, 2000. 1 Gold, 1 Silver, 1 Bronze, 2000 Sydney Paralympic Games. "Jean Driscoll Day" held in various cities throughout the U.S.

Event(s): Wheelchair Marathon, 10K, and 10,000m Track Event

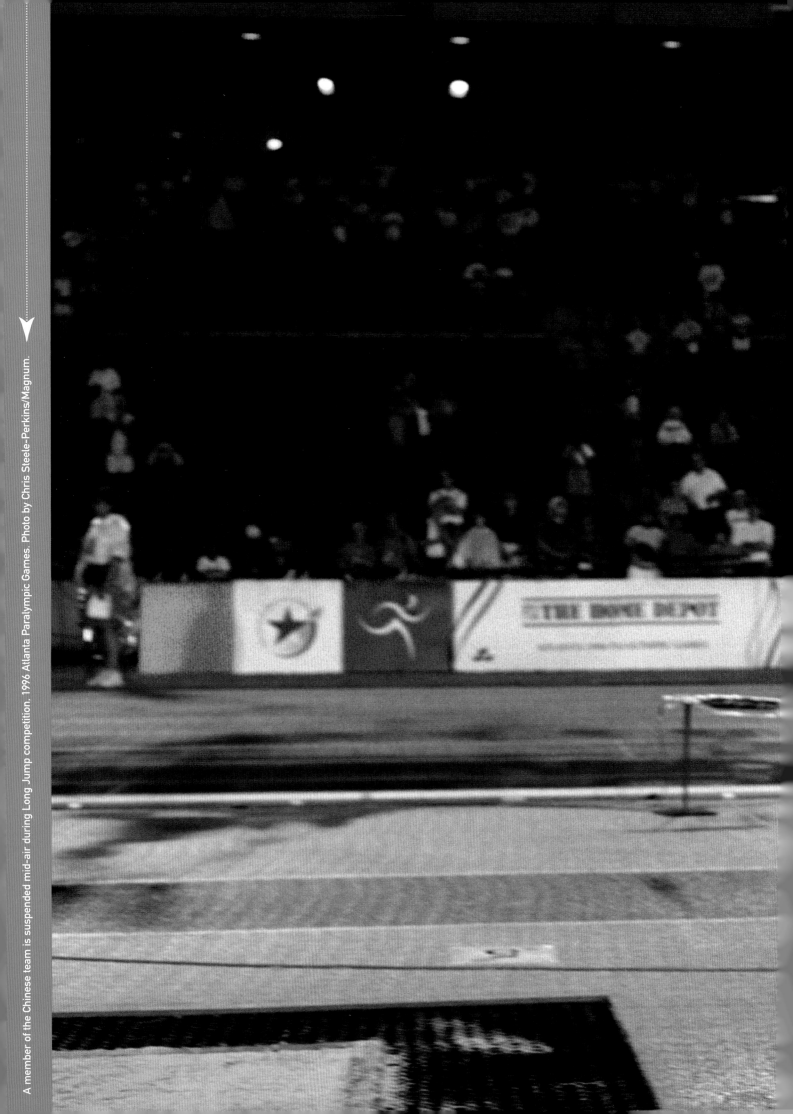

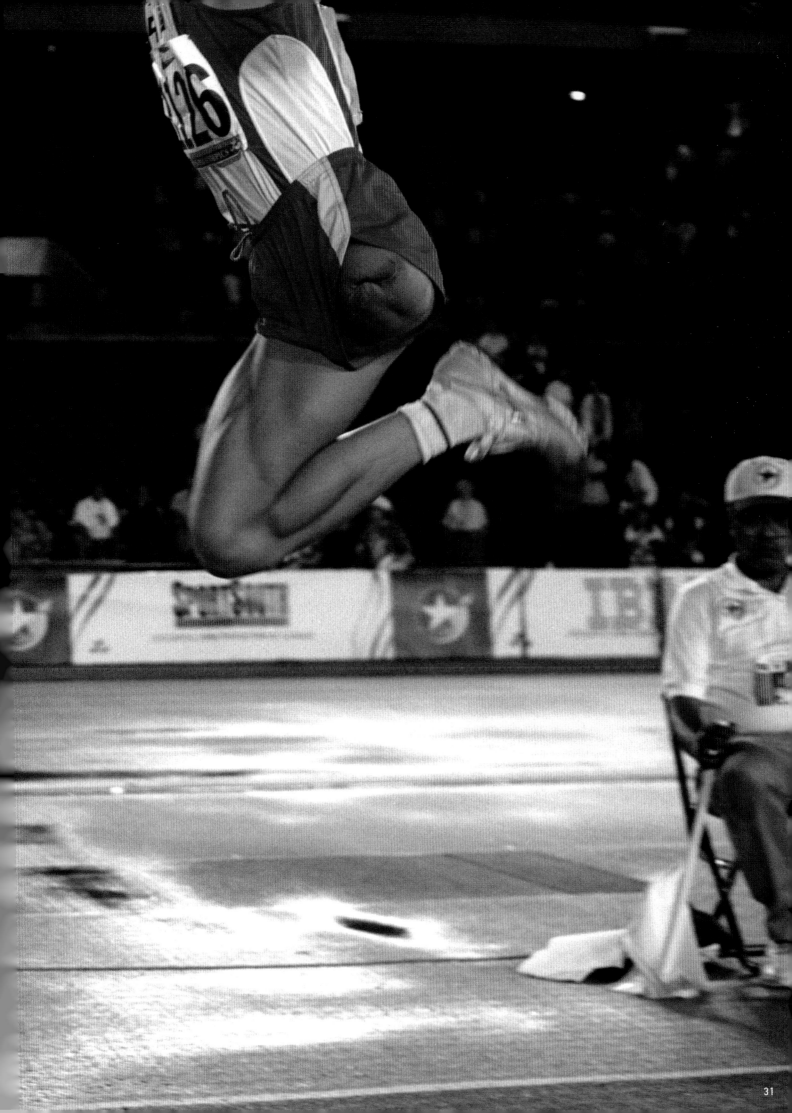

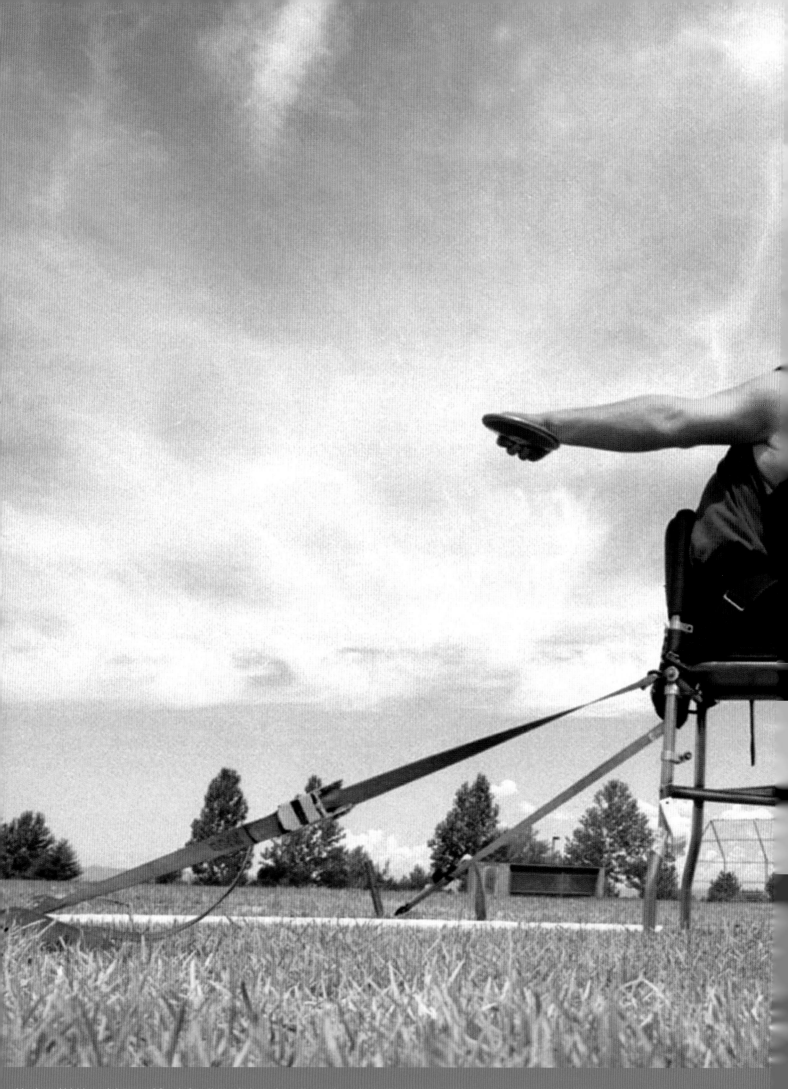

Matthew Aldridge, eighteen, of South Carolina, winds up for a discus throw in the finals of the 1999 Wheelchair Sports USA National Wheelchair Championships.

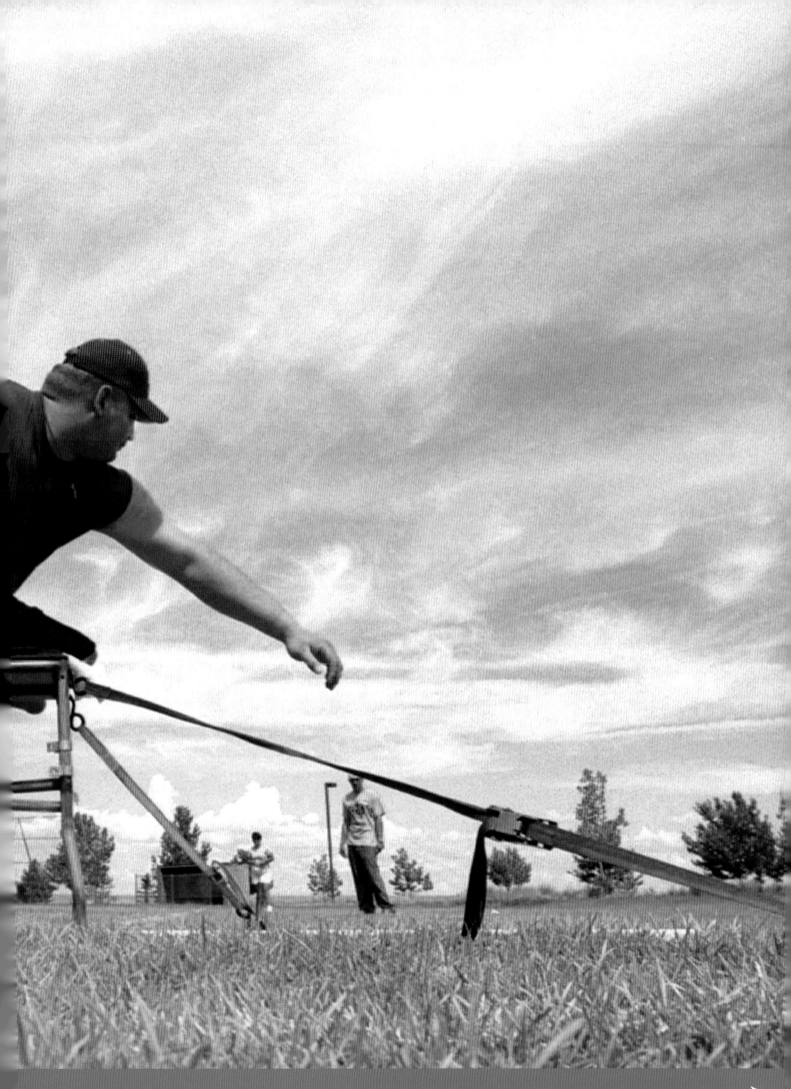

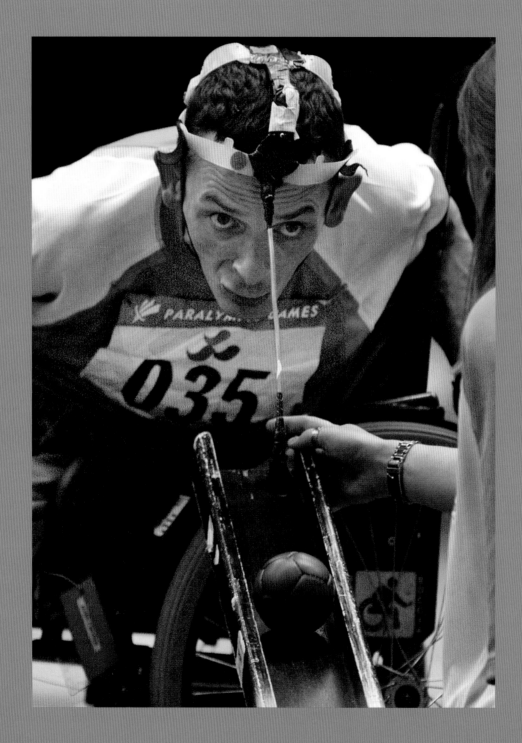

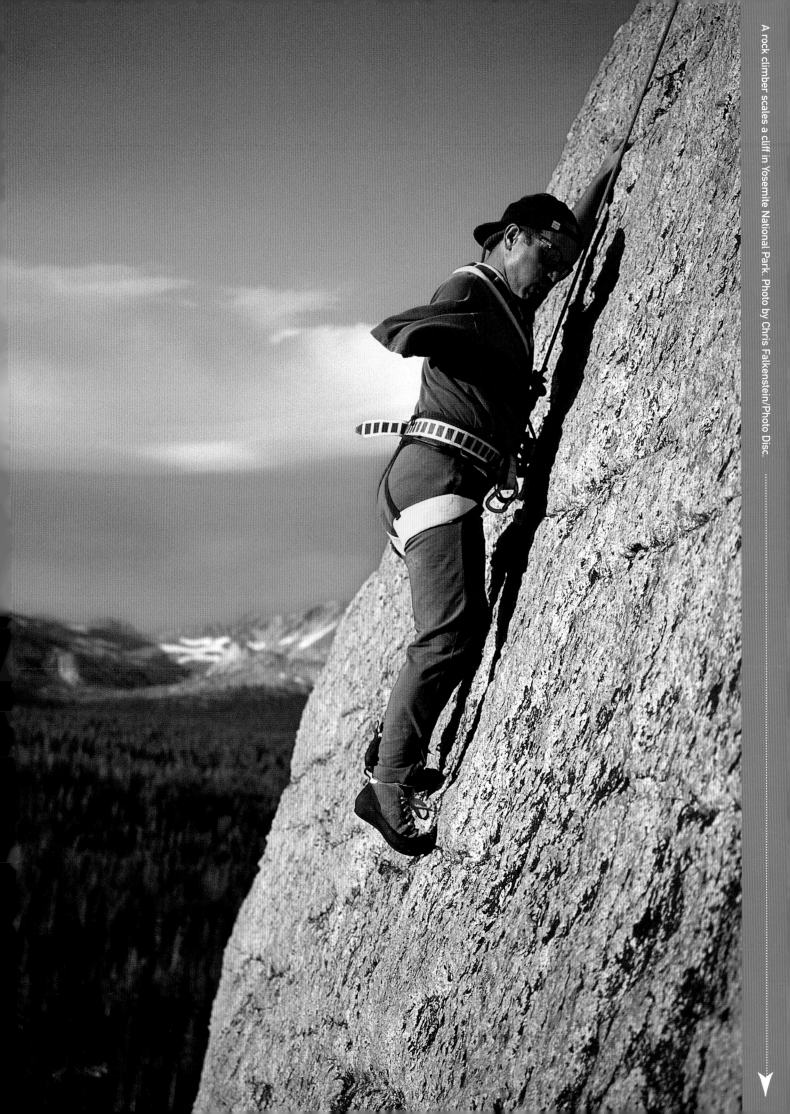

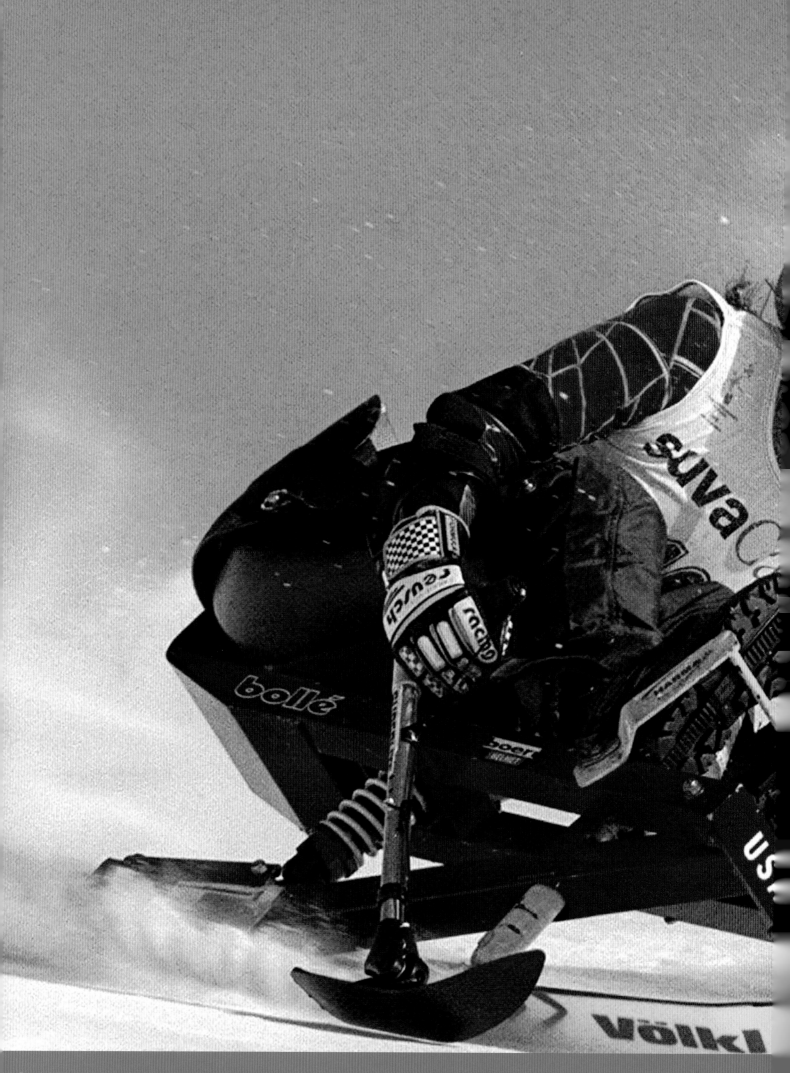

Sarah Will of the United States clears a gate on her way to a win at the Women's Downhill Race of the 6th World Ski Championships for the Disabled.

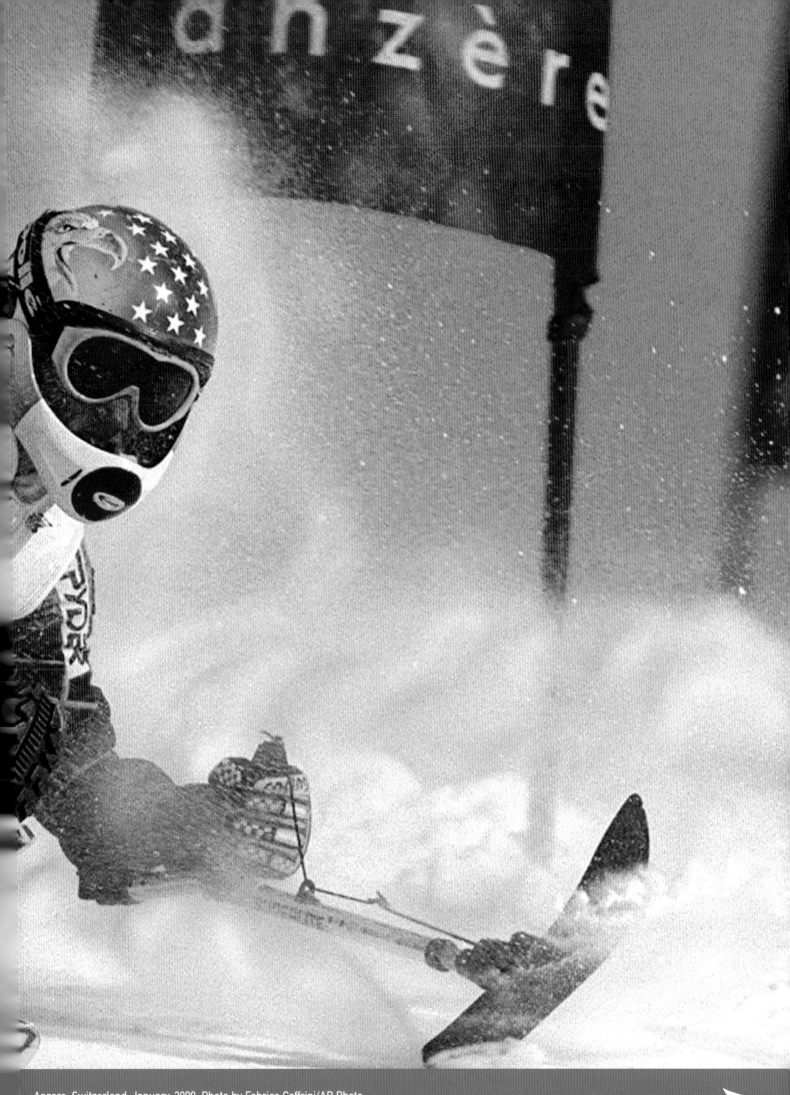

"

Wheelchair sport is extremely competitive. It isn't for the people who need it; it's for the people who want it. To hear a group of racers discuss the next athlete to be left from the pack by a series of surges for a $15,000 prize isn't feel good athletics. Or to hear basketball players in the huddle during a national championship game identify a player on the other team who will be exploited because he is more paralyzed, isn't the Special Olympics. There is no "Pollyanna" attitude in wheelchair sports, but there does exist simultaneous camaraderie and pedigree competition.

Through participation, athletes exercise their option to make choices. These choices define a person as an active participant in their community. From simple community involvement to the glory of the Paralympics, a person who chooses to lead an active lifestyle is breaking down attitudinal barriers, creating avenues for change, in all settings. It is our responsibility to positively affect the world with the skills that have been provided us. As a result of this movement, persons with disabilities have gained equal opportunity and access to a broad range of recreational and sports activities, from neighborhood playgrounds to Paralympic competitions.

Upon participation as a Paralympian, a door is opened to a very secret place that will never be closed. Changed forever, you obtain a degree of knowledge that others, who have never made an international team, will never know. It's like hearing the very first cry of your firstborn or surviving a war. These events are perhaps meaningless to the ones who have not participated, but to the participant, the change is understood.

If enough work has been done and greatness arrives, winning a Gold medal opens a window to the soul, where every emotion ever felt is kept. At the moment your opponent is defeated, there is a rush of uncertainties. As if eliminating the last of twelve enemies after being cornered for ten days, psychologically the effort continues because it has been the only thing you've known for months. For just a moment you wonder, "Is it really over?" Reality then permeates from everywhere.

Everyone within sight—including the other warriors who have spent the last four years of their lives preparing to be in your place—are looking right at you as your national anthem is played and your flag is raised. Even so, that moment doesn't hold a candle to the value of the everlasting memory you will have.

In my personal opinion, Paralympians are better athletes than our able-bodied counterparts. We work just as hard, do it for a lot less money, carry education to our venue as well as competition, and have overcame a major debilitating accident to arrive. Our stories display the true resiliency of mankind, therefore better matching us with the way life really exists. Though people have been sold the idea that Olympic athletes are the perfect version of man, in reality they are the athletes who don't represent the whole of society. We represent the idea that competitiveness comes down to more than just how hard you train.

"

RANDY SNOW (United States)

Highlights: Multi-sport medalist at the 1984 Stoke Mandeville Games (Track), 1992 Barcelona Paralympic Games (Tennis), and 1996 Atlanta Paralympic Games (Basketball); 10-time US Open Wheelchair Tennis Champion; ITF World Tennis Champion; Jack Gerhardt Award (Wheelchair Heisman Trophy); Vice Chair, USTA Wheelchair National Committee; USTA and USPTR Player of the Year; Producer, Award Winning Video (*Turning POINT*); DS/USA Athlete of the Year; National Council on Disability, Outstanding Disabled Citizen; USTA National Community Service Award; Honorary Chairperson, Barbara Jordan Awards

Event(s): Wheelchair Tennis, Basketball, and Track

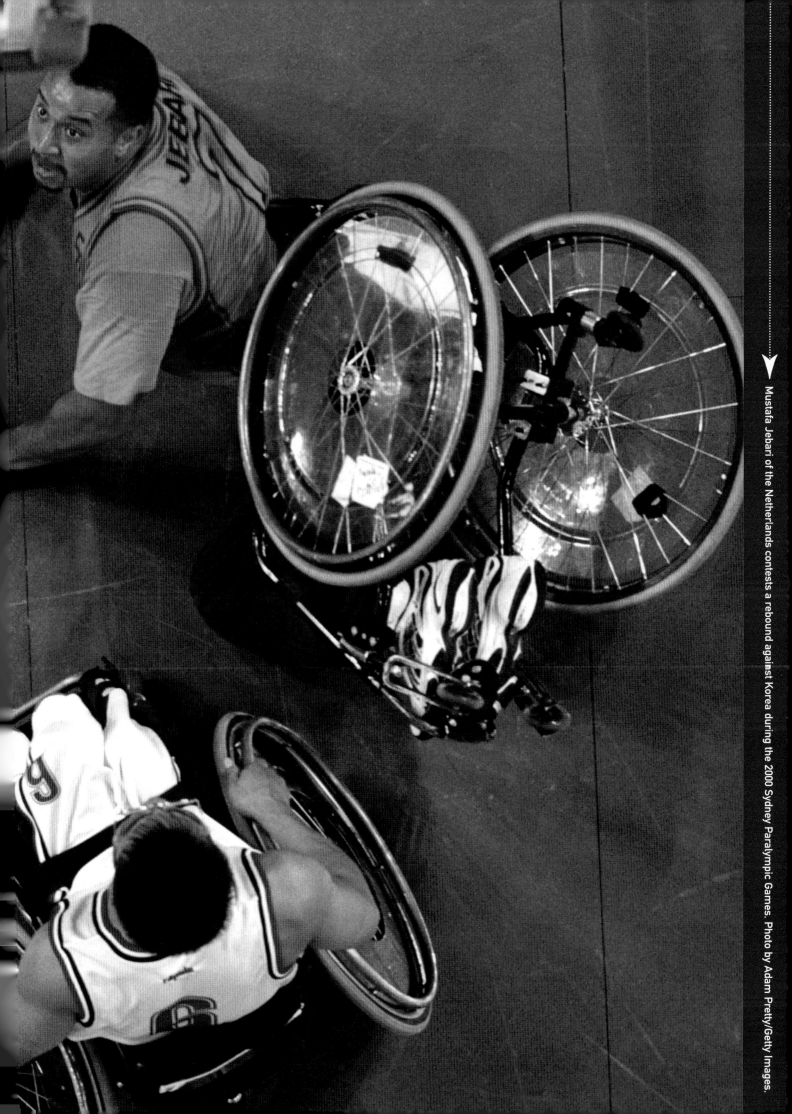

Mustafa Jebari of the Netherlands contests a rebound against Korea during the 2000 Sydney Paralympic Games. Photo by Adam Pretty/Getty Images.

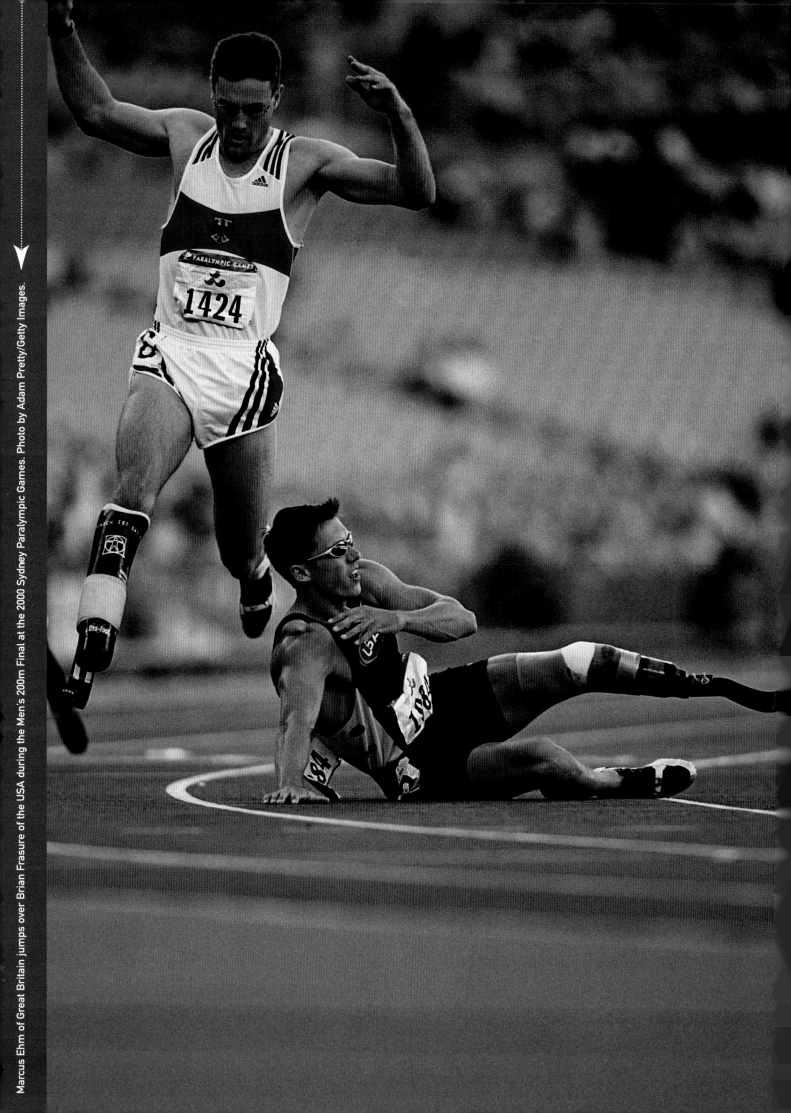

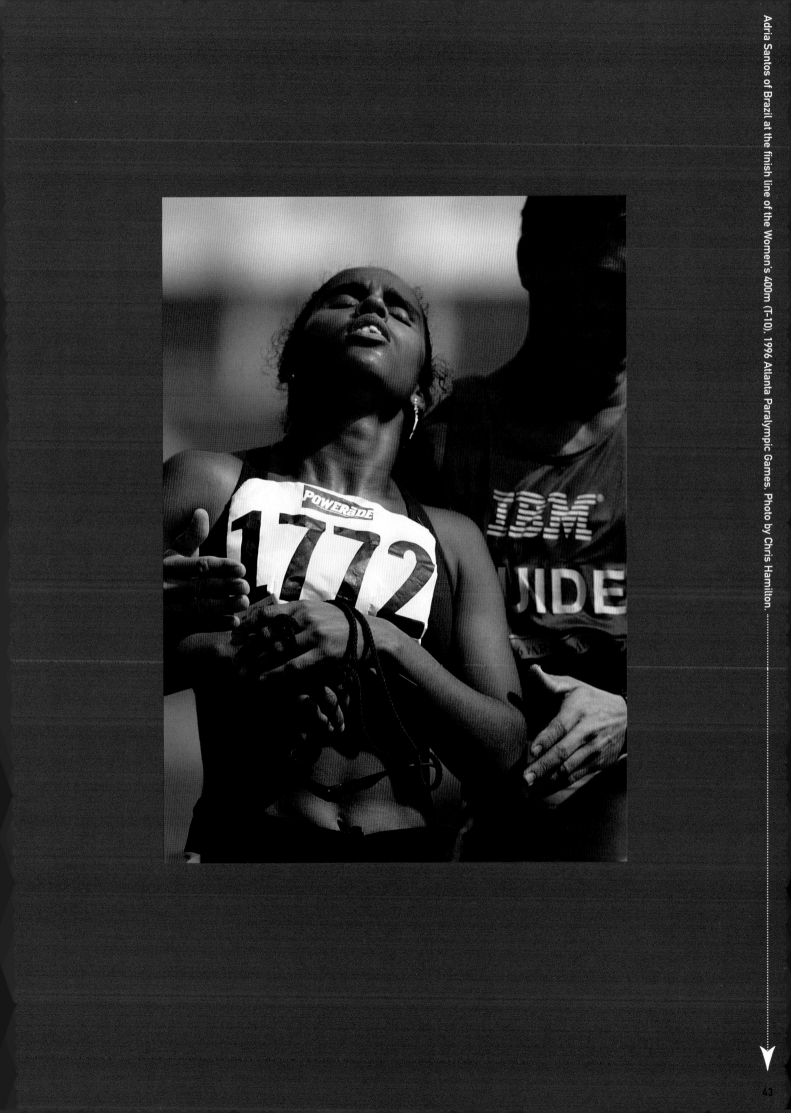

Adria Santos of Brazil at the finish line of the Women's 400m (T-10), 1996 Atlanta Paralympic Games. Photo by Chris Hamilton.

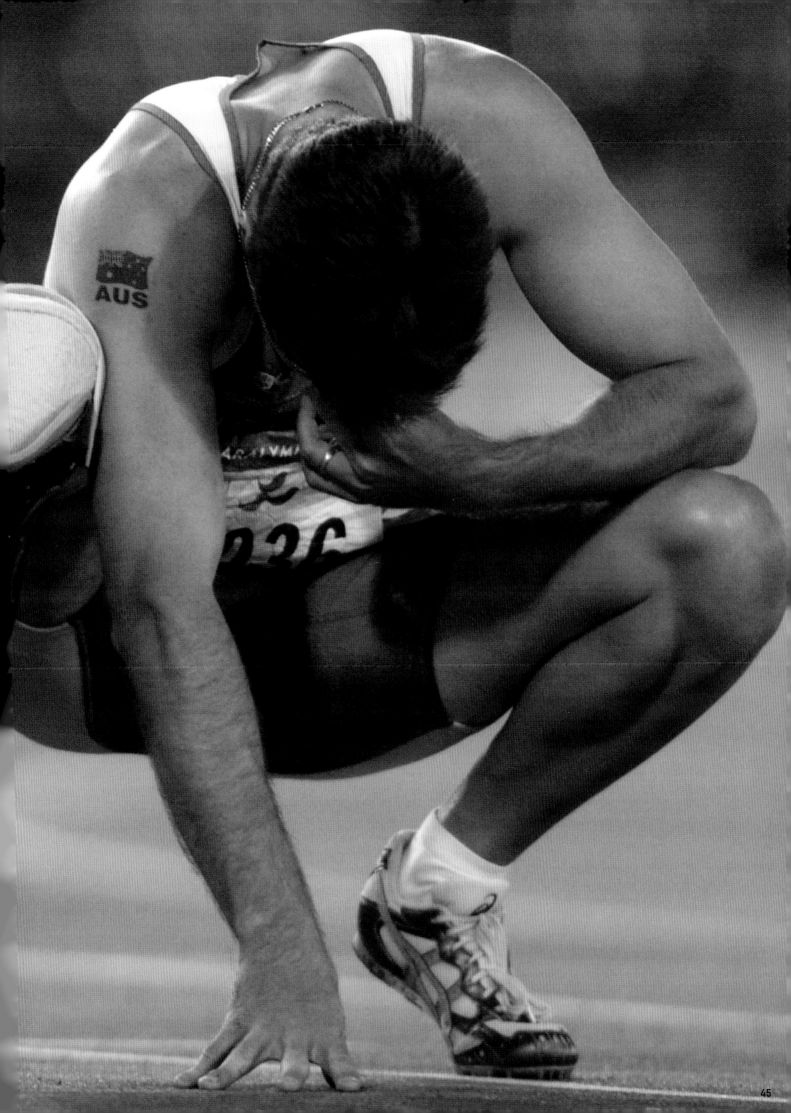

"

The pleasure of sports is to discover at every moment that you have arrived and you have overcome—that you have achieved your goals, which you thought to be possible only in your dreams. One of the biggest discoveries in my career as a rower is to be able to notice, over the course of the years of training with the "able-bodied" rowing section, the prejudices and the ideas of the identical training of a paraplegic and an "able-bodied" rower.

It is all about discovery. If you played sports without uncertainty, then there would not be competition. My discovery, as somebody handicapped, is that swimming opened the door to everything for me. First, it gave me freedom, then a place in society. I believe that life is only worth living if it brings novelty and pleasure every day. Sports reflect this at every level. There is a lot of enjoyment and disappointment; the competition allows high stakes.

You can lose yourself by giving into revenge, or you can win by making it your objective to improve—and forbid revenge to overcome you. Pleasure and enjoyment are constant ingredients which must always be present, as well as respect for oneself and others; then it is possible to go the distance. You have to believe in it. Sport, above all, should be a search for an expression of the body and of the spirit. It is essential to approach sport first as a game, and then to transform that game into work, while still holding onto the pleasures of the game. Life is essentially the same struggle. You begin by playing, then you learn by playing, and

My goal for the future is to be as useful to the sport as it was useful for me. The image of a successful athlete who is also of a mother of a family and a balanced and happy person with a handicap should **allow others to hope.** My sports career of twenty years is coming to an end. My thirst for competition is satisfied, and I believe that it is necessary to know how to stop wanting to win, even when you know you still might be able to.

"

eventually, you are able to work and enjoy the pleasures of the game. A person should choose a sport as one chooses a profession; it's very personal. You gradually develop your capacities due to continually raising the bar. Freedom of spirit is, for me, a keyword in my sport and my success. I have a handicap, and swimming was an obligation that metamorphosed into pleasure because it gave me freedom. In the water my handicap does not exist anymore. Water allows me to travel out of the universe of the patient and into that of the person who wins. Water freed me to be myself and to be recognized as such.

BÉATRICE HESS (France)

Highlights: 4 Gold medals at the 1984 New York Paralympic Games; 3 Gold and 1 Silver at the 1985 European Championships, Vienna; 1 Gold in 25m Back Stroke, 1 Silver in 50m Freestyle at the 1988 Seoul Paralympic Games; 6 Gold and 1 Silver at the 1996 Atlanta Paralympic Games; received the title of Knight of the Legion of Honor (Chevalier de la Legion d'Honneur), 1996; 6 individual Gold medals and 2 Gold medals in Relay Event at the 1997 European Games, Badajoz, Spain; 5 Gold and 2 Bronze at the 1998 Christchurch World Championship, New Zealand; 7 Gold and 1 Silver in 50m Butterfly at the trials for the European Championship in Brauschweig, Germany; 7 Gold at the 2000 Sydney Paralympic Games

Event(s): Swimming (50m Butterfly, 50m Backstroke, 100 and 200m Freestyle, among others)

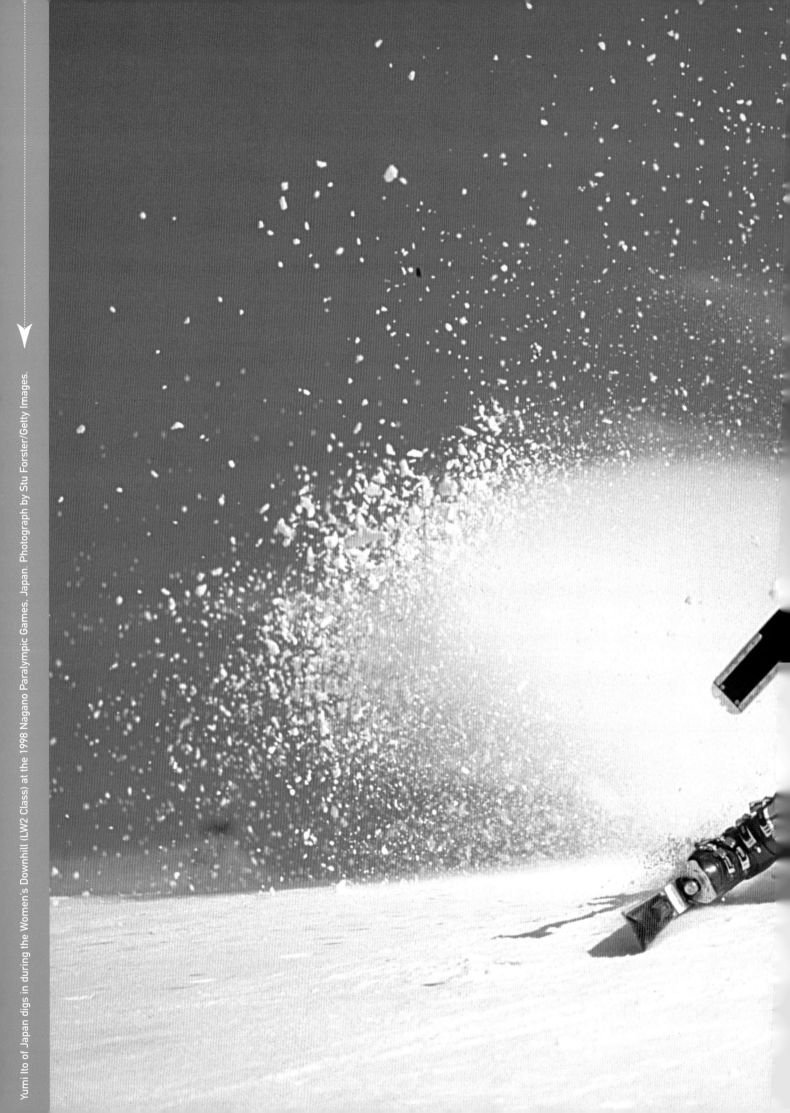

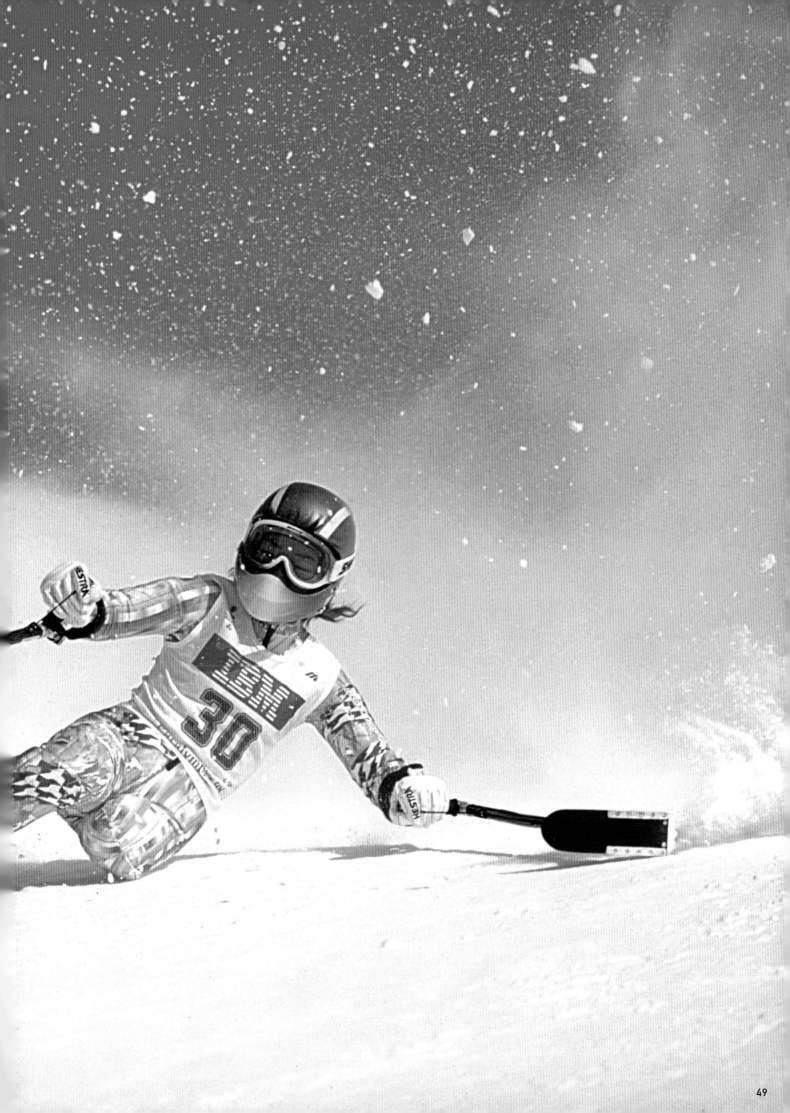

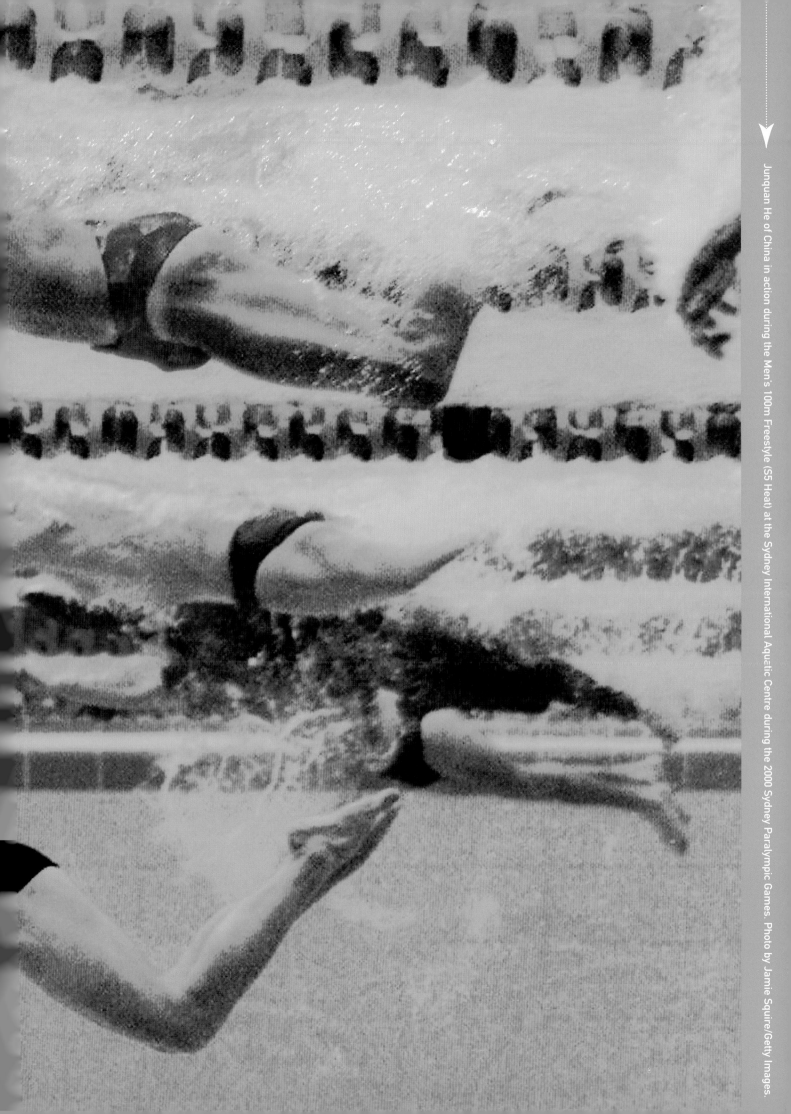

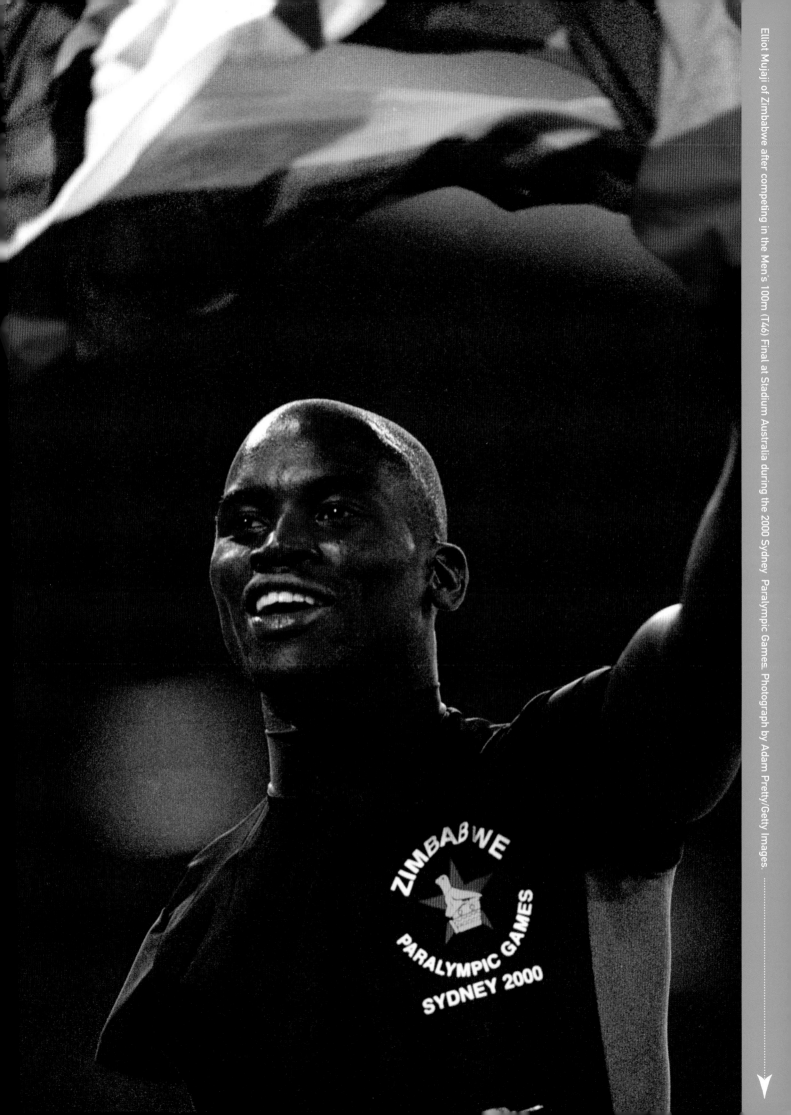

JAYNE CRAIKE (New Zealand)

Highlights: Silver medal in 1999 World Championships; Gold in Individual Dressage and Silver in Freestyle Dressage (Grade IV), 2000 Sydney Paralympic Games; Member of Order of Merit by Queen

Event(s): Equestrian (Dressage)

"I have to believe that there is still more to come in a world that is continually changing, and that we can make a difference in educating people—disability sports are more than a therapeutic tool; they are an avenue for people with a dream who are driven to achieve no matter what disability they have.

As long as the community as a whole—athletes, supporters, organizers—keep being visible, international disability sports can only grow. Public awareness and support is the key to development around the world. We must ensure that those to follow us continue to get the support that is needed and that a more equal playing field is provided by sporting bodies."

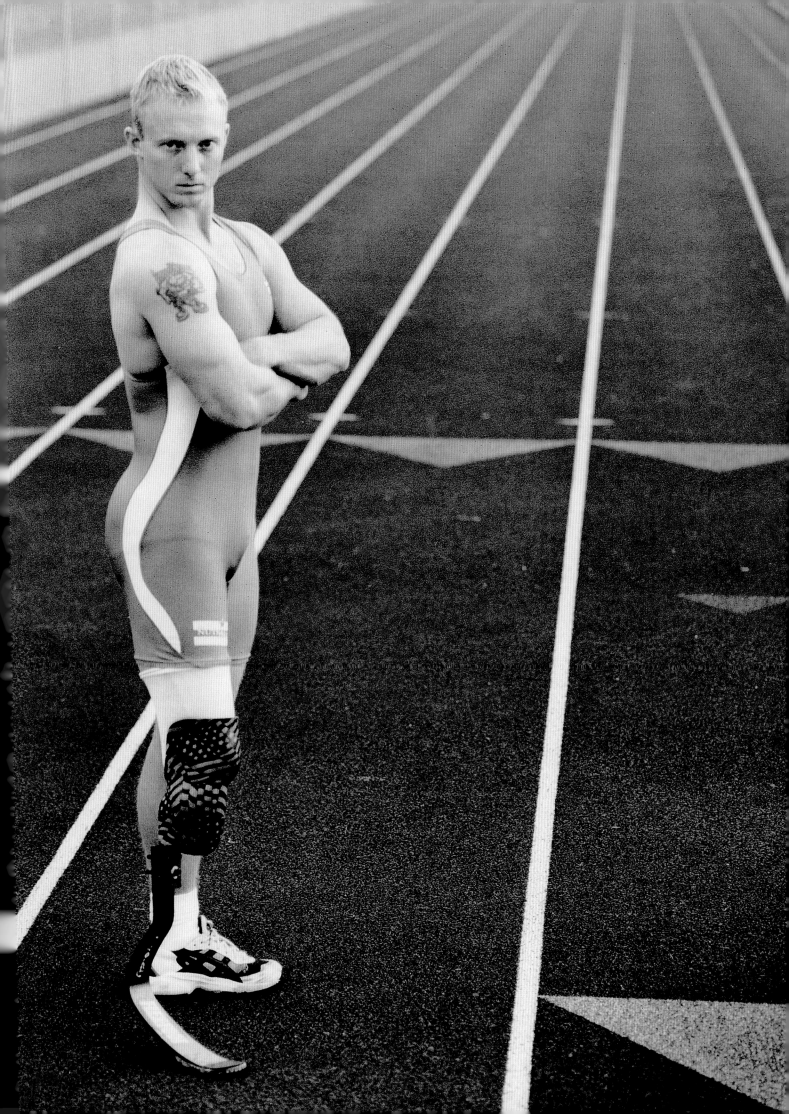

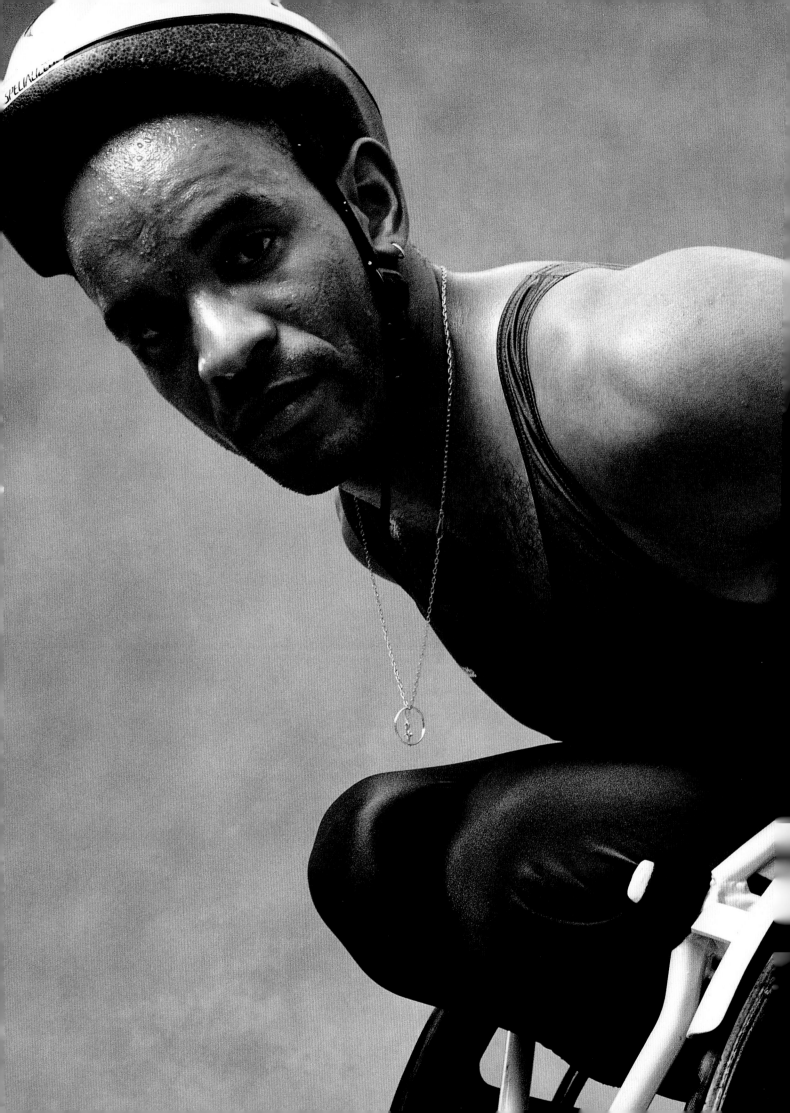

CLAUDE ISSORAT (France)

Highlights: 3 Gold medals and 2 World Records in 100 and 200m at the 1992 Barcelona Paralympic Games; World Champion at 1994 Berlin Championships; named Elite Athlete by the Secretary of Sports and Youth, 1994; 3 Gold medals at the 1996 Atlanta Paralympic Games; Winner, 1996 Medal de Service des Sports; Medal de Chevalier de la Legion d'Honneur and Médaille Echelon d'Or du Ministère de la Jeunesse et des Sports; Gold and Silver medals at the 2000 Sydney Games.

Event(s): Wheelchair Racing; 100, 200, and 1500m

Photo by Jan Michael

ANN ROMNEY (United States)

Highlights: Member of the U.S. Dressage Federation, Reserve Champion in Equestrian/Dressage (Region 5, 4th Level Adult Amateur)

Event(s): Equestrian (Dressage)

"

The airwaves carry sport competition virtually every hour of every day. But for some reason, every two years, the world stops to witness the Summer or Winter Olympics and, increasingly, the Parallel Olympics, or Paralympics. It cannot be sport alone that accounts for the attention of one half of the world's population; most of these same sports draw sparse audiences at other times. I believe that the power of the Games is that they showcase great qualities of humanity. Courage, sacrifice, perseverance, dedication, and even faith are displayed time and time again.

For many of us, the combination of superb athletic performance and qualities of the spirit of humankind are most striking in the Paralympic Games. The extraordinary alpine turns of Chris Waddell both amaze and inspire. We recognize uncommon effort and determination.

Three years ago I was diagnosed with Multiple Sclerosis. Nothing has brought more to me during this time than the sport of equestrian dressage. While I may never reach the high achievement of international equestrian competition, I am driven beyond my limitations by the challenge of sport. As I watch the Paralympians, I know that they have had to climb mountains to reach the pinnacle of their athletic performance; I also know that in doing so they have, in some measure, healed themselves.

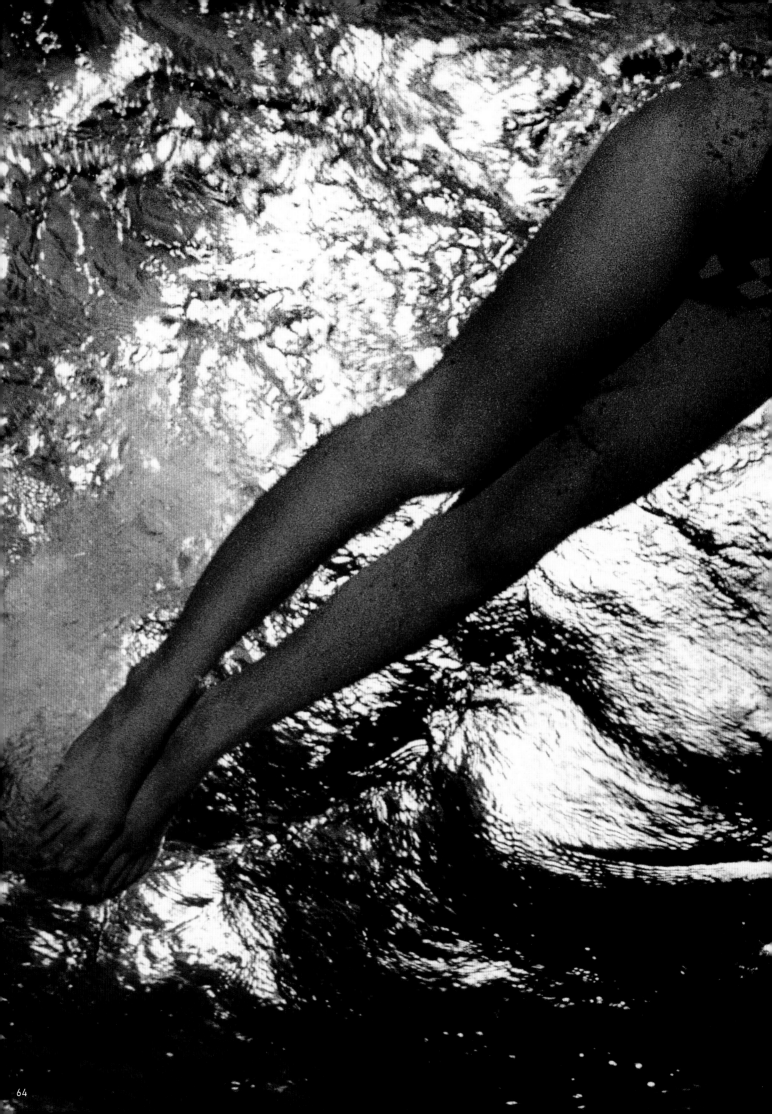

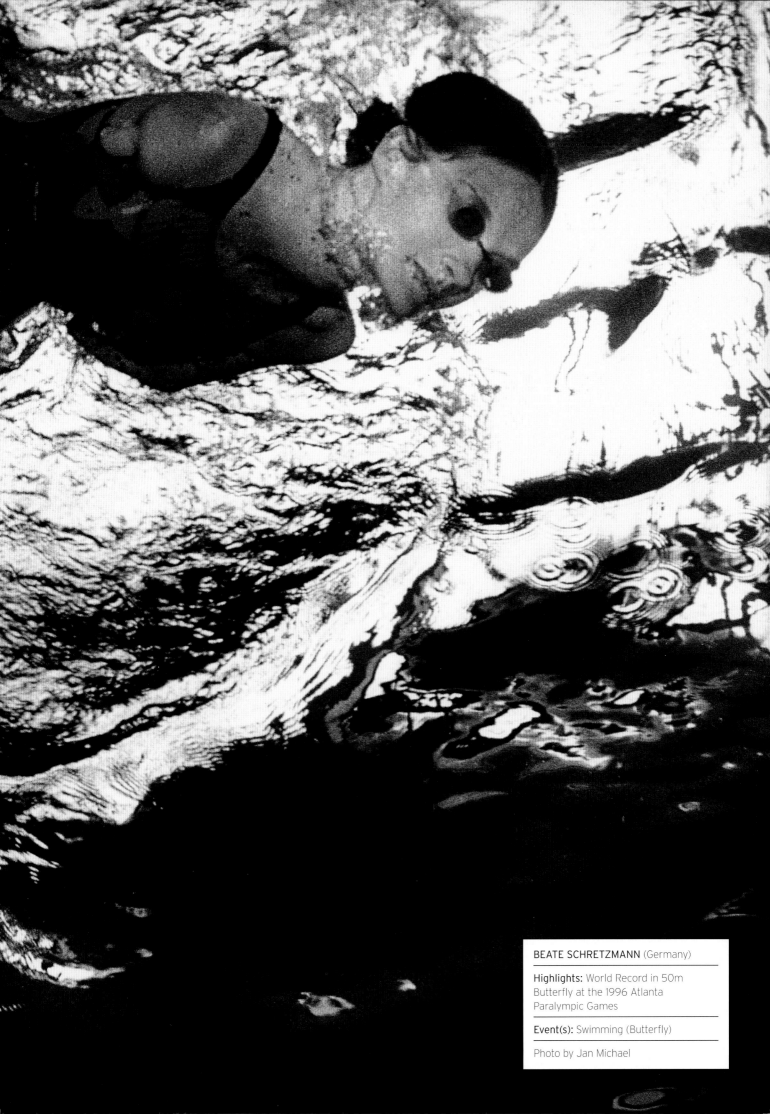

BEATE SCHRETZMANN (Germany)

Highlights: World Record in 50m Butterfly at the 1996 Atlanta Paralympic Games

Event(s): Swimming (Butterfly)

Photo by Jan Michael

SARAH BILLMEIER (United States)

Highlights: 6-time World Champion;
7 Paralympic Gold medals in the 1990s;
Recipient, Arete Award for Courage in
Sports; Member US Olympic Committee
Athletes Advisory Council; Member,
US Disabled Ski Team

Event(s): Alpine Ski

"

The nature of sport is to keep pushing faster, further, stronger. This sort of eternally striving courage is a welcome label for disabled athletes, however we are often also saddled with the other connotation of courage that assumes a disabled person is brave if she lifts her head off the pillow and dares to live a life. In my experience the only way to eliminate the latter attitude is to live the way you want to and to let your actions speak for themselves.

I look at my life and I am awestruck at how lucky I am. My life is brimming with wonderful people, love, resources, and the freedom to follow my goals and dreams. I have the most wonderful family and friends who have always supported me along the way. If I am in a race and needing a push I think of Erik Weihenmayer, who climbed Everest, or Paul Martin, who does Ironmans, and skiing becomes not so hard in comparison. My teammates are always finding ways to go faster and to keep up: I have to do the same.

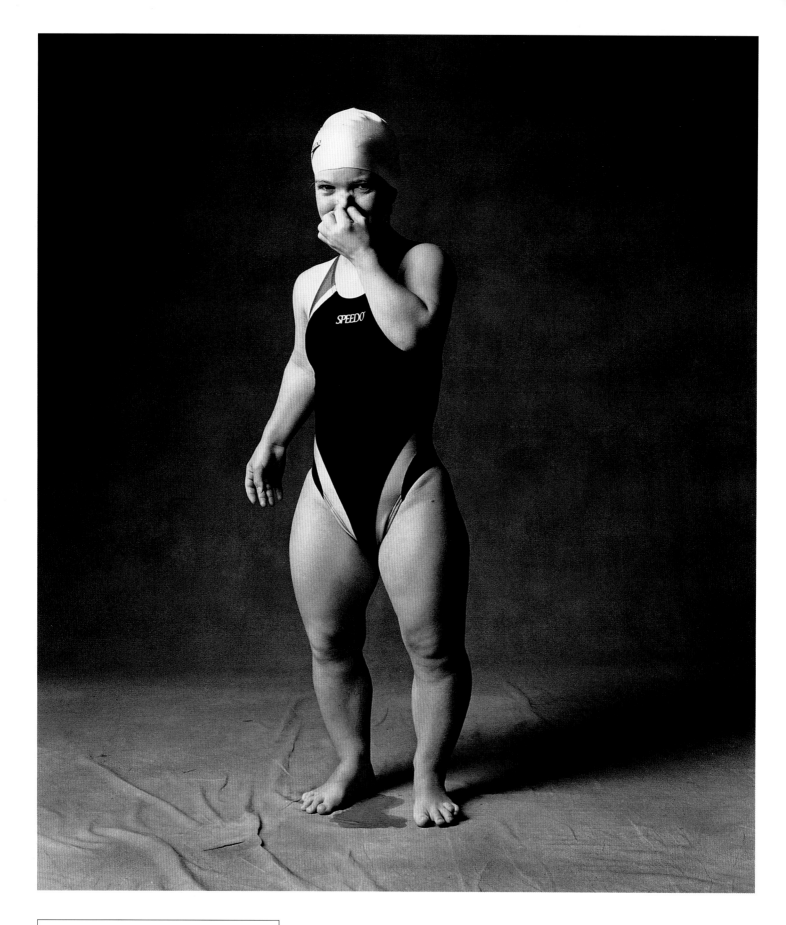

MARIA GOETZE (Germany)

Highlights: Bronze medal in 100m Breaststroke at the 1992 Barcelona Paralympic Games; Bronze at the 1996 Atlanta Paralympic Games; Bronze at the 2000 Sydney Paralympic Games.

Event(s): Swimming

Photo by Jan Michael

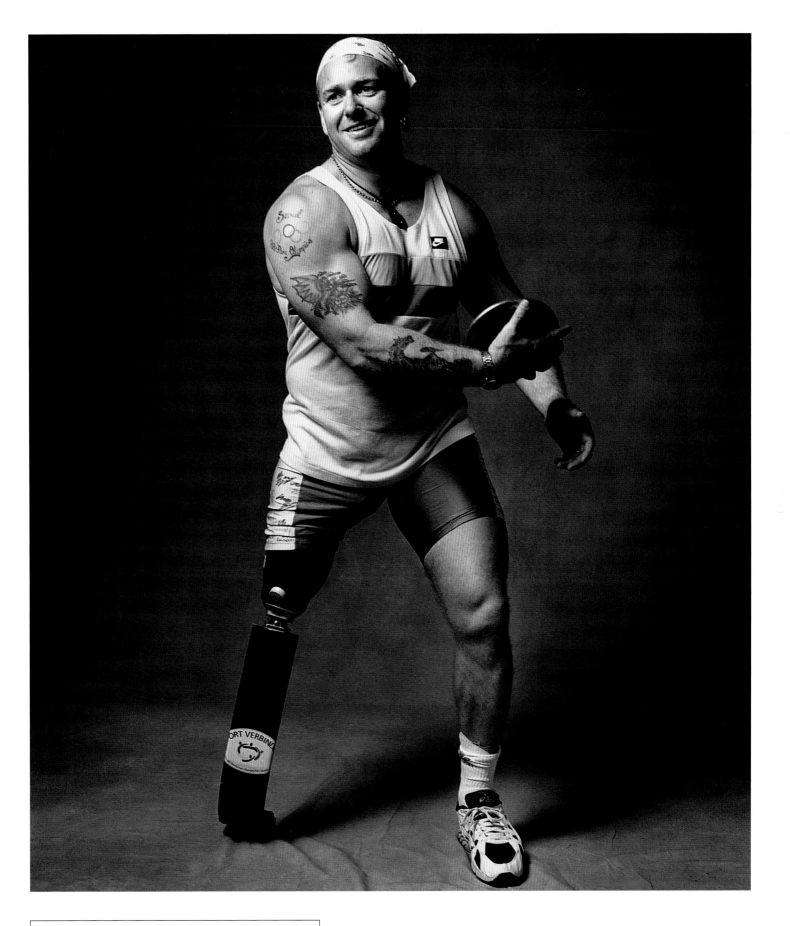

JOHN EDEN (Australia)

Highlights: Silver medal in Discus at the 1992 Barcelona Paralympic Games; World Record, 1994 Berlin World Championship; 1 Gold in 100m at the 1996 Atlanta Paralympic Games; Bronze in Discus, 1996 Atlanta Paralympic Games.

Event(s): 100m and Discus

Photo by Jan Michael

EMILY JENNINGS (Great Britain)

Highlights: Gold medal in 200m at the 1996 Atlanta Paralympic Games; 5 Gold at the 1997 BT National Long Course in Sheffield, UK; 1 Silver and 6 Gold at the 1997 European Championships in Badajoz, Spain; *Daily Express* Parallel Sportswoman of the Year, 1997; 3 Gold, 1 Bronze, and 3 World Records at the 1998 Swedish Open Championships; 1 Gold, 1 Silver, and 2 Bronze medals at the 1998 IPC Swimming Championships in New Zealand; 1 Gold, 3 Silver, and 1 Bronze, and 1 European Record at the 1999 European Championships; Gold and Silver medals at the 2000 Sydney Paralympic Games; Voted Sportswoman of the Year at the 2000 Leicester Mercury Sports Award ceremony.

Event(s): Swimming (Backstroke, Freestyle, Butterfly, among others)

Photo by Richard Bailey

"

I think people are a little uncomfortable with the unknown. Participating in sports, climbing mountains—these things confront the fear of the unknown by bringing people together. When people work together, they become a much stronger force.

I don't see myself as a crazy blind guy. I see myself as someone who uses innovation and a lot of ingenuity. I take a situation that looks impossible and try to figure out how to attack it, how to make it possible.

People can't figure out how the words blind and climber go together, so it's been fun trying to show people that they can and do belong in the same sentence. My goal has always been to surpass people's expectations. Sometimes when those expectations become boundaries, I want to just get rid of them altogether. Sometimes we write off things as impossible a little too quickly. To reach the summit is to say, "Look at what is possible." It takes those narrow parameters and shatters them.

We can all get to the top—we just have to figure out our own way to do it.

ERIK WEIHENMAYER
(United States)

Highlights: First blind man to summit Mount McKinley, 1995, Kilimanjaro, 1997, Aconcagua, 1999, Vinson Massif, 2001, Mount Everest, 2001; On track to join 100 elite climbers world-wide who have scaled the seven summits; Recipient of ESPN's Arete Award for Courage in Sports; the Free Spirit Award of the Freedom Foundation, and the Lifetime Achievement Award from the Glaucoma Foundation; Author of *Touch the Top of the World* (2000)

Events: Wrestling, Mountaineering, Rock and Ice Climbing, Skydiving, Skiing, Biking

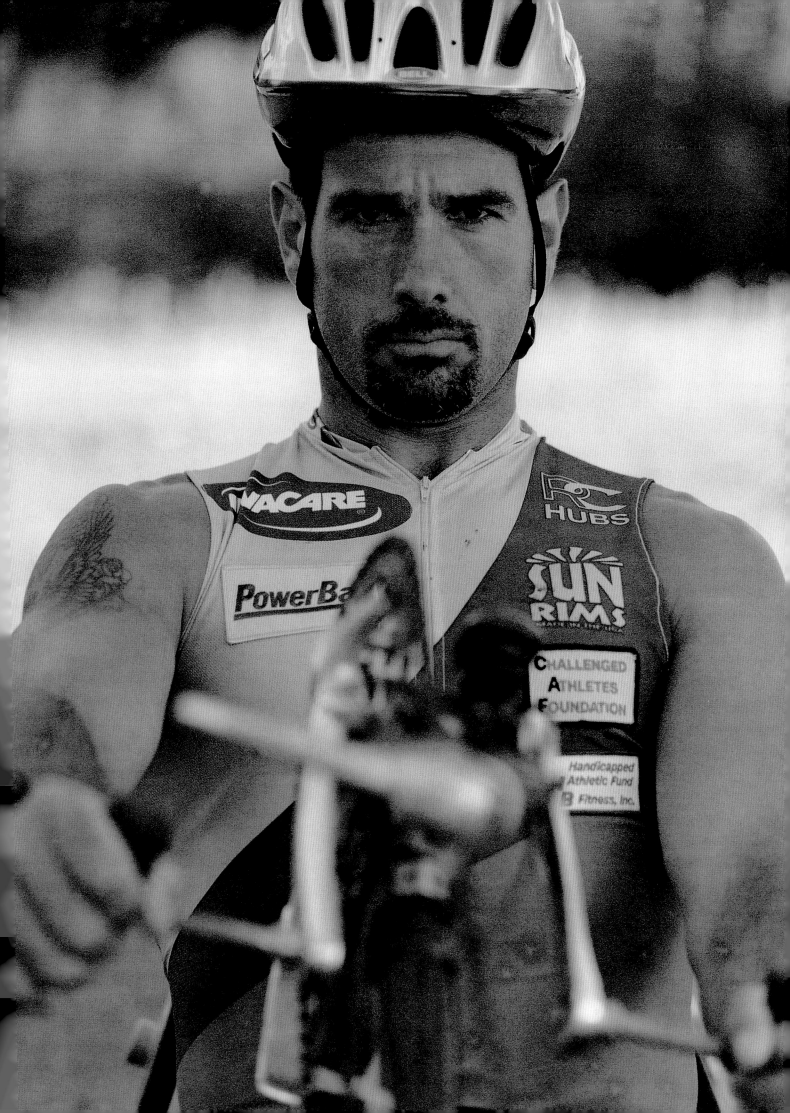

GIAN MARIA DAL MAISTRO
(Italy)

Highlights: 1st place, 1997
European Championship,
Baqueira Beret; Gold medal in
Super-G, Silver in Slalom and
Giant Slalom; Silver in Downhill
and Giant Slalom, Bronze in
Slalom at 1998 Nagano Games;
World Cup in 2001.

Event(s): Skiing: Downhill,
SuperG, Giant Slalom, and
Slalom (B3 Catagory)

"

I don't have any pretensions about being a star. Basically, I ski because I like to and if I get good results, I feel great. I see myself as any other member of society—no more, no less. I started skiing at the age of six, thanks to my uncles. But if I continue to ski today, it's because I have so much fun; I feel incredibly alive every time I come down a hill. There's no single person who influences my sense of self. My thanks go out instead to a collection of people—everyone who has been near me in each moment of joy and through each moment of difficulty— now and in the things I hope to do in the future.

I have confidence in the future of disability sports, and I'm aware that slowly but surely it will gain more visibility and more popularity. It's important to learn from the past and move forward, making steady improvements all the time.

BARRIE LANE (Great Britain)

Highlights: 2nd place in 1995 (July) Invitational
Tournament at Gravesend; 1st place in 1995 (August)
Invitational Tournament at Gravesend; 9th place at the
1996 Atlanta Paralympic Games; 6th place at the 2000
12th BBS International Tournament in Hounslow; 12th
place at the 2000 Sydney Paralympic Games.

Event(s): Goalball

Photo by Richard Bailey

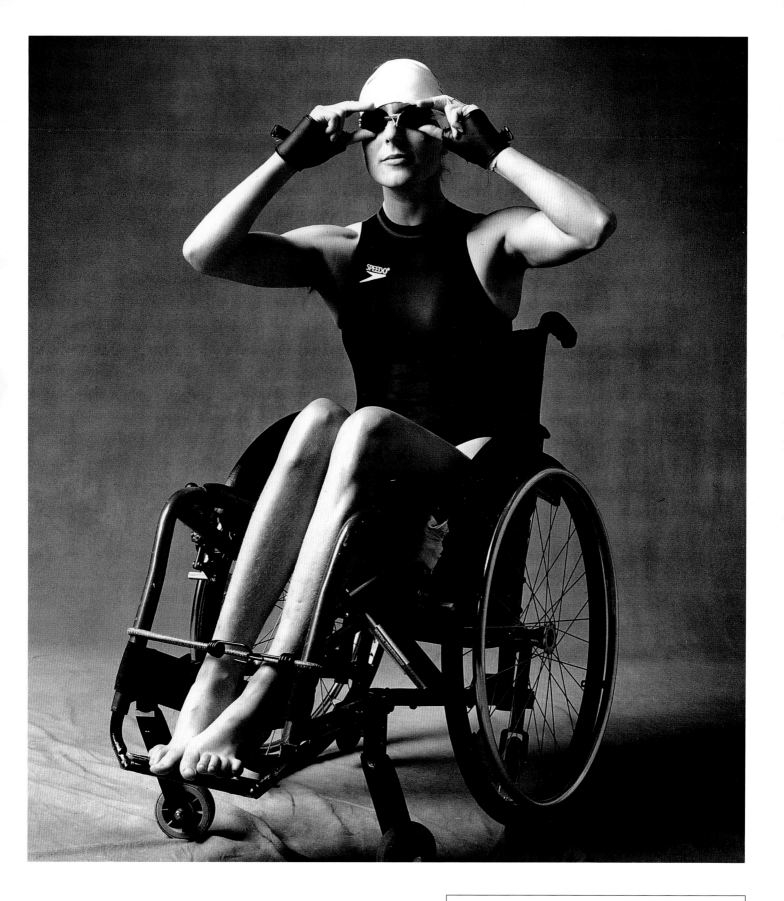

KAY ESPENHAYN (Germany)

Highlights: Record in the 50m Freestyle at the 1995
European Swimming Championship for the Disabled in
Perpignan, France; Record in 200m Freestyle, 1996 Atlanta
Paralympic Games; 3 Gold medals, 2 Silver, and 1 Bronze
at the 1996 World Championship; 5 Silver at 2000 Sydney
Paralympic Games.

Event(s): Swimming

Photo by Jan Michael

Richie Powell (Great Britain)

Highlights: 8-time runner in the
London Marathon, including 6th place,
200m; Gold medals in the 100, 200,
and 400m, 1991 British Track
Championships; 7th place Integrated
Marathon, 1991 Commonwealth
Games; 2nd place 1992 Dublin
Marathon; 5th place 4 x 100m-relay,
1998 IPC World Championships; 1st
place and new Course Record Time
2001 Nike Swansea Bay 10K

Event(s): Track and Field (Marathon,
10K, 100, 200, 400, 800m,
4 x 100m relay)

Photo by Richard Bailey

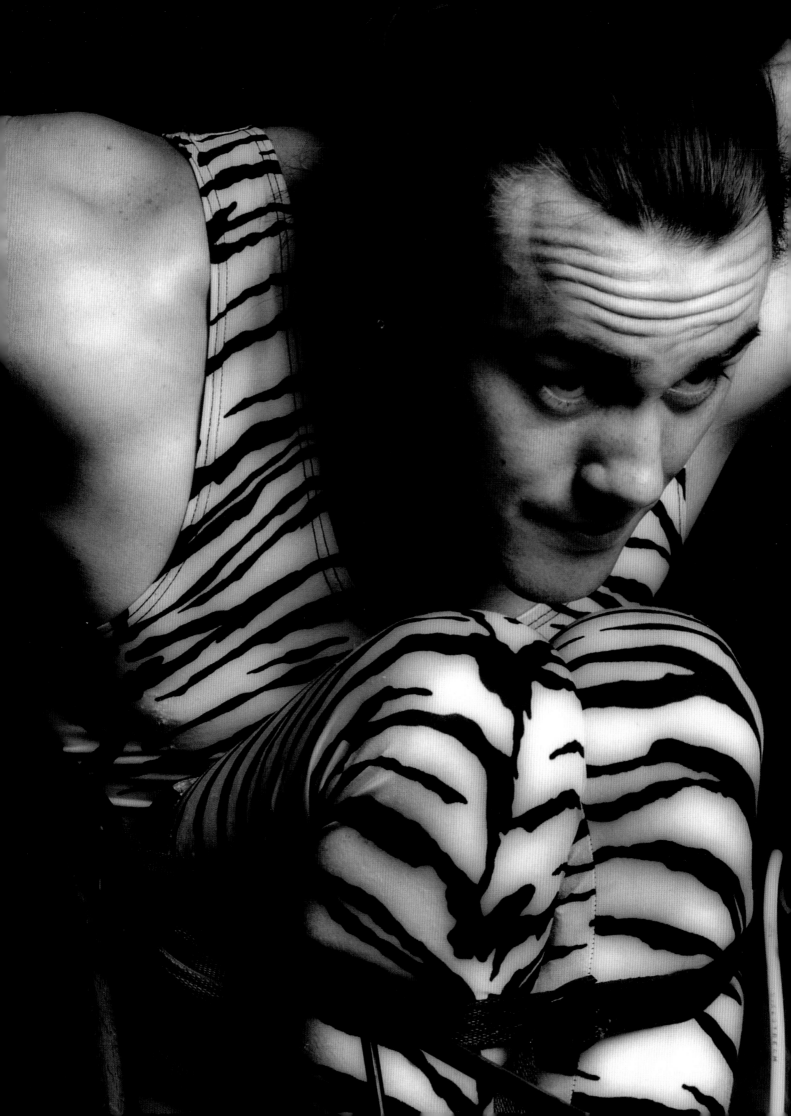

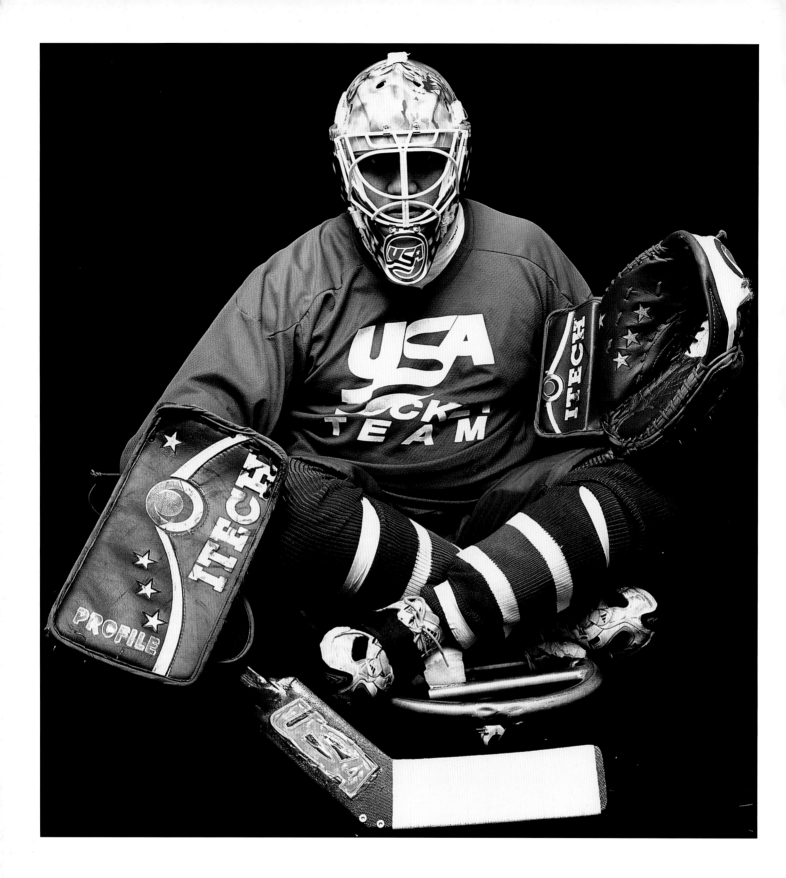

MANUEL GUERRA JR.
(United States)

Highlights: Silver medal, 1993 World Championship; 1993 and 1997, World All-Star Goalie, IPC Swedish Winter Games; Silver, 1995 IPC Swedish Winter Games; Member, 1998 Nagano US Paralympic Team

Event(s): Ice Sledge Hockey

Photo by Jan Michael

MIKI MATSUE (Japan)

Highlights: Gold medal and World Record, 1500m; Gold, 1000m and 500m, Silver, 100m in 1998 Nagano Paralympic Games; 5th place Ice Sledge Hockey Team, 1998 Nagano Paralympic Games; 4th place Ice Sledge Hockey Team, 2000 World Championship

Event(s): Ice Sledge Racing, Ice Sledge Hockey

Photo by Jan Micheal

"

Even in childhood I had a profound sense of one-ness: body, mind, and soul.

After my accident in 1987, I wanted to find out what life could be with a prosthesis. Running has always been a natural thing to me; I couldn't be without it. I am a competitive person. I like sports because of the rules and the fairness. To go all the way to the Paralympic final and finally succeed was an experience that brought me a big step forward in developing my self-confidence. Competing is my way of being a "peaceful warrior." And true freedom is freedom from the need to do or to achieve something. Freedom from my point of view is to see what motivations lie behind my desires and to realize that it is just my ego wanting to be satisfied. Giving up at the right moment is not a bad thing. As a matter of fact, it can save your life. The important thing is to know when it's time to stop. Every human being has their own individual frontiers: to extend my own frontiers is my task.

LUKAS CHRISTEN (Switzerland)

Highlights: Silver medal, 1992 Barcelona Paralympic Games; World Champion 100, 200m, and Long Jump at 1994 World Championship in Berlin; Gold, 100, 200m, and Long Jump at the 1996 Atlanta Paralympic Games; World Champion for 20m and Long Jump at the 1998 International Paralympic Committee World Athletic Championship in Birmingham, England; World Record in 200m; 2 Gold (200m and Long Jump) and 1 Silver (100m) at the 2000 Sydney Paralympic Games; Sportsman of the Year 2000 and Central Swiss Sportsman of the Year 2000; World Record Holder Long Jump

Event(s): Track and Long Jump

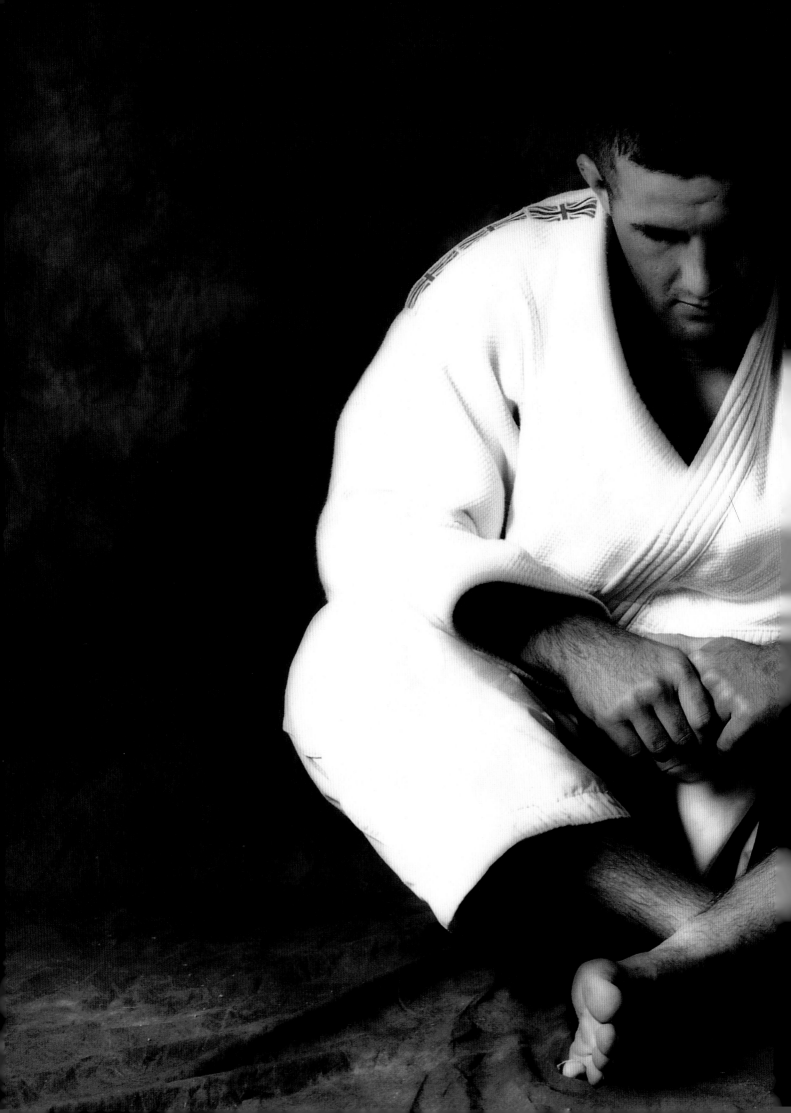

SIMON JACKSON
(Great Britain)

Highlights: Won all European
Championships from 1987-95;
2 World Championships in 1990
and 1995; 3 Gold medals at
1988 Seoul Paralympic Games,
1992 Barcelona, and 1996
Atlanta Paralympic Games

Event(s): Judo

Photo by Richard Bailey

GREGORY TAYLOR (United States)

Highlights: Outstanding Quad Award at the 1997 Southeastern Regional Games, U.S.; 1998 Brown Cup recipient for Excellence in Athletics; Completed the ASAP Cycle to the Sea (a three-day 170 mile handcycle ride from Charlotte, NC, to Myrtle Beach, SC to raise money for the Charlotte Institute of Rehabilitation's Adaptive Sports and Adventure Program) in April 2001; Co-captain of the CIR Carolina Crash rugby team; 8th Place, 2001 Division Two Finals

Event(s): Handcycling, Quad Rugby, and Tennis

Photo by Mike Carroll

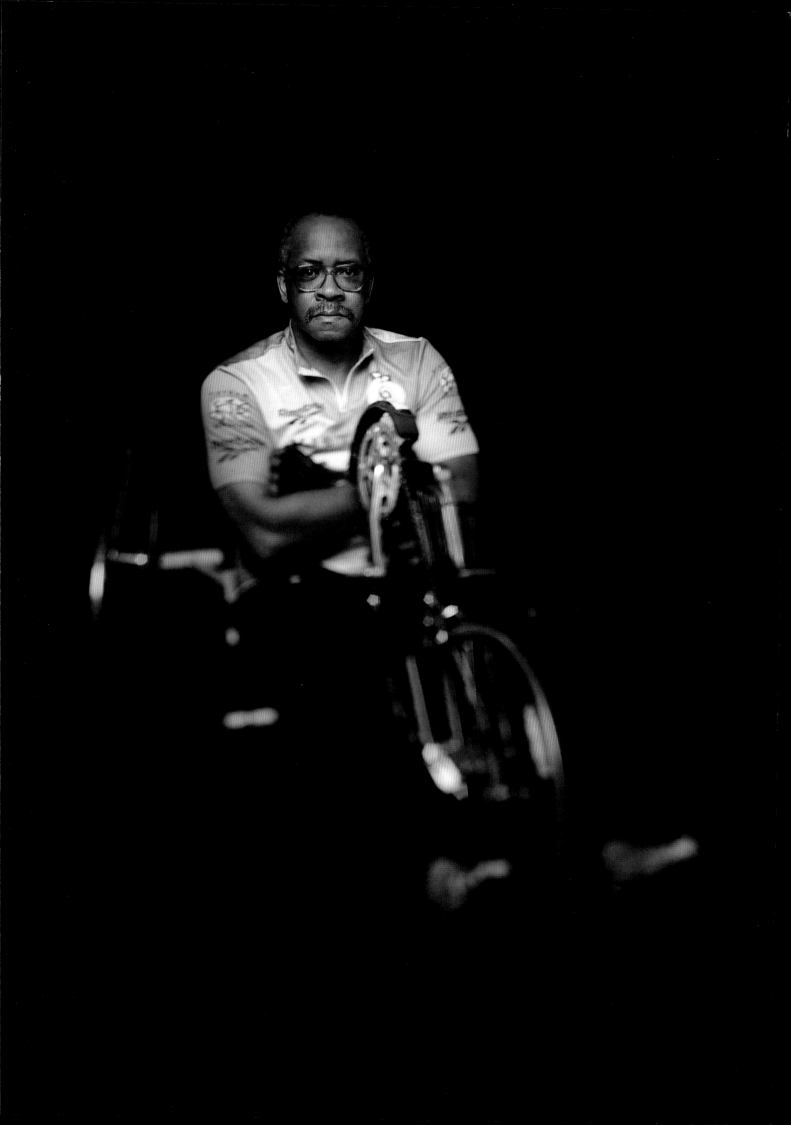

PETER HULL (Great Britain)

Highlights: 3 Gold medals and 3
World Records at the 1992 Barcelona
Paralympic Games; Swimming Record
in the 100m Freestyle, 1995 European
Swimming Championship for the
Disabled in Perpignan, France; Swimming
Record in the 50m Backstroke at 1996
Sheffield Championships

Event(s): Swimming

Photo by Jan Michael

PAM FERNANDES (United States)

Highlights: 8-time National Champion, 1993-2000, Road and Track; Silver medal, 1994 World Championships For Disabled Cyclists, road race (pilot Mike Rosenberg); United States Association Of Blind Athletes' Female Athlete Of The Year, 1995; Bronze, 1996 Atlanta Paralympic Games, 1K Time Trial, (pilot Mike Rosenberg); Current National Record Holder, set in Colorado Springs 1999, 200m Time Trial (pilot Al Whaley); Gold and World Record Holder, 2000 Sydney Paralympic Games, 1 K Time Trial (pilot Al Whaley); Silver and Paralympic Record Holder, 2000 Sydney Paralympic Games, 200m Time Trial & match sprints (pilot Al Whaley); Double Gold, 2001 European Championships For Disabled Cyclists, Zurich, Switzerland, 1K Time Trial and Match Sprint (pilot Al Whaley). United States Olympic Committee's Olympic Spirit Award, February 2001

Event(s): Cycling

" I've often said if we could somehow bring the respect, dignity, and camaraderie of the Paralympic Village to the rest of the world, we would teach a lifetime of lessons in a single day. We sometimes use the term Paralympic Movement. The Paralympics is more than a two-week sporting event. It is a mind set, an attitude, and a way of life. It is all about possibility, equal opportunity, and teamwork. Once exposed to the Paralympics, people's lives are inextricably altered and forever empowered. The power of the movement is with the people whose lives it touches. We need to expose more people to that world. Then awareness will increase, doors will open, and everyone will benefit.

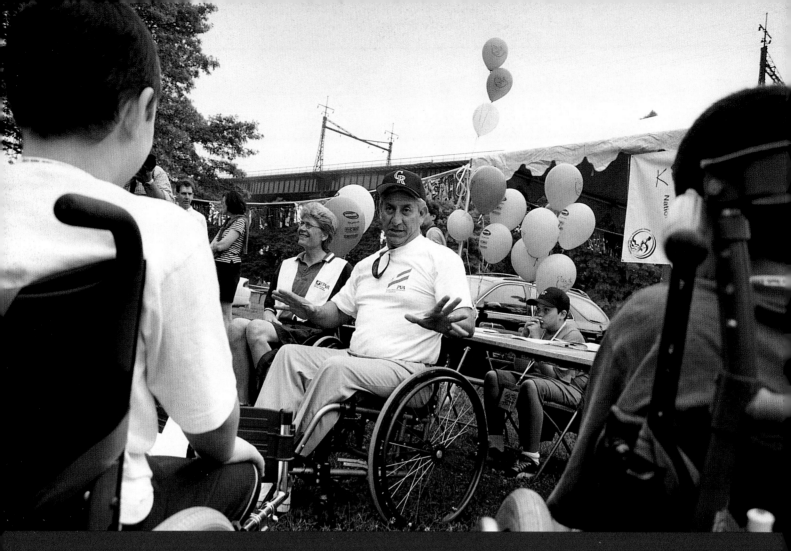

The Paralyzed Veterans Association hosts the National Wheelchair Games every year. The 2001 Games in New York City featured a Kids Day program.

Veterans and athletes Artie Guerrero (top left), Laura Schwanger, (top right, bottom left), were on hand to work with teens and children. Photographs by Jay Nubile.

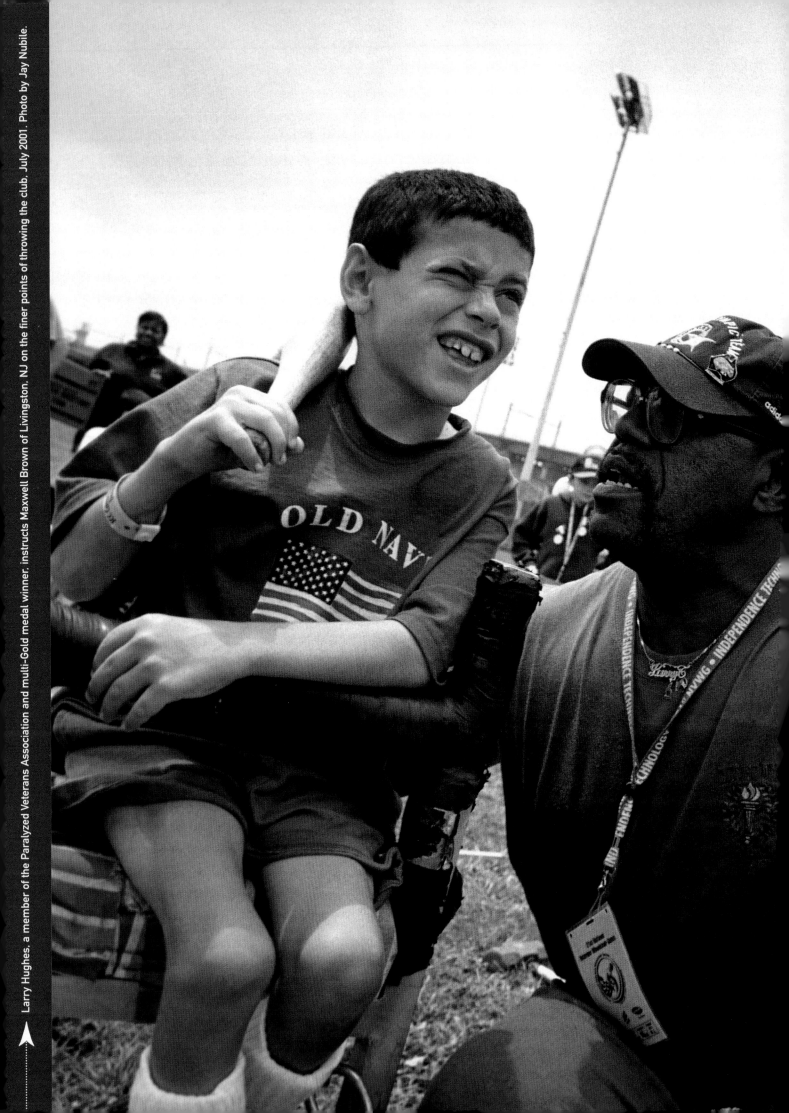

"

I became involved in the lives of people with disabilities very young. Two of my cousins were born with Muscular Dystrophy. I spent a great deal of time with them, constantly adapting things so that they could be involved. This experience translated well into a career in therapeutic recreation. I started Northeast Passage because many of the people I had worked with in rehab hospitals talked about the gap in services between the day you leave rehab and what the general population has to offer. Northeast Passage was developed to fill that gap in service using recreation and sport as the primary tool to help people re-engage in their communities and families, improving their quality of life and functional skills.

The importance of integrating events cannot be overstated. The more non-disabled individuals see people with disabilities living life and competing the less discrimination there will be throughout all aspects of life from basic access to employment. Sport has always been a medium that dissolves barriers, supersedes conflicts, and fosters understanding. If given the chance, disability sports will follow that same path.

I hope that in the future, international disability sports will gain more visibility and mainstream acceptance. For that to happen, we in the field need to pay more attention to feeder and recreation programs. This is not just to produce the next great athlete but to produce an audience. We have to make disability sports relevant to other people with disabilities and to the general population. We cannot afford the "super crip" image. We must get more average people with disabilities out in public and into the workforce being active. We have to move from a special interest story to a sports story.

JILL GRAVINK (United States)

Highlights: Jill Gravink, CTRS is the Founder and Director of Northeast Passage, a community-based program which uses sports and recreation to increase independence and quality of life for individuals with physical disabilities and their friends and families. Northeast Passage is a program of the University of New Hampshire.

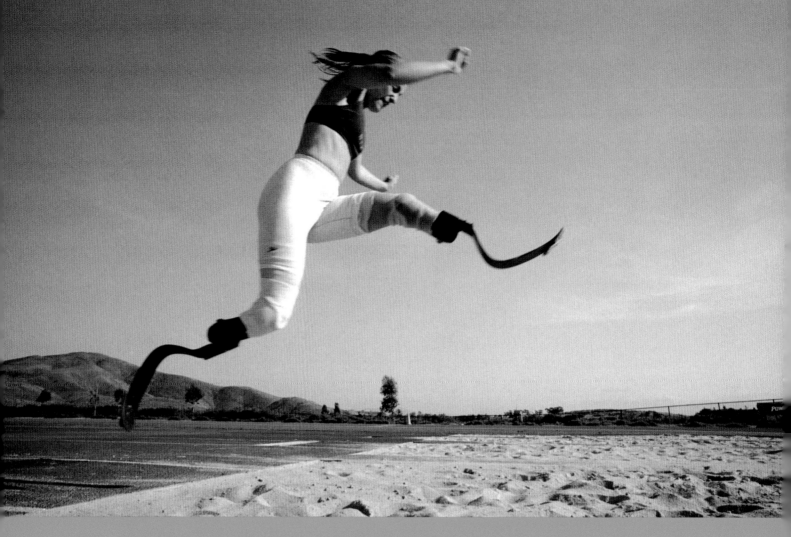

Gold-medal winner and fashion model Aimee Mullins has become a high-profile spokesperson for the disabled community.

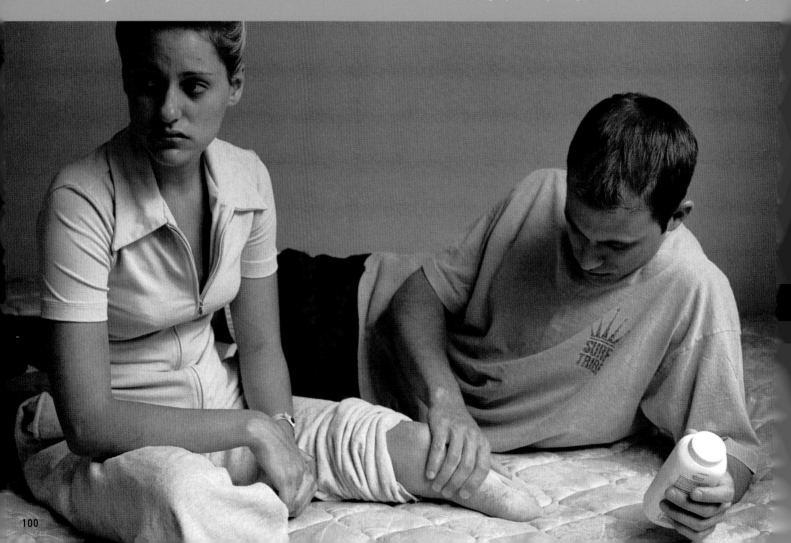

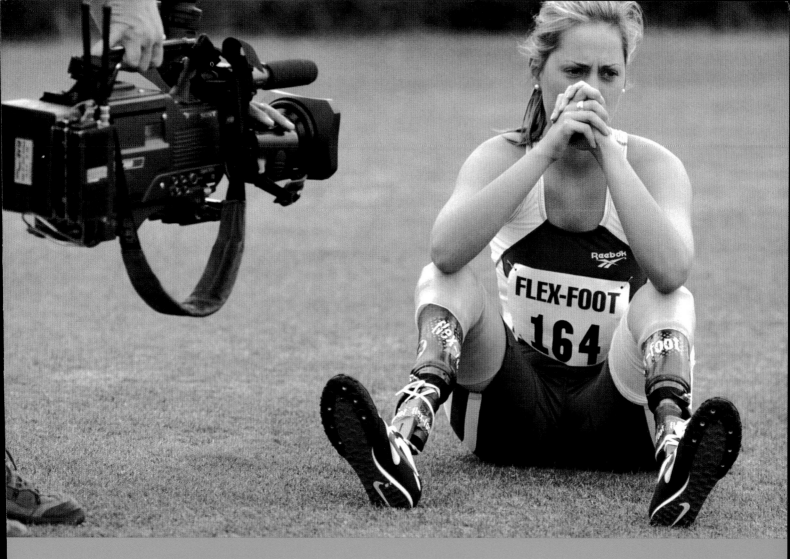

These images take us behind the scenes of training and competition in San Diego, and at home in Washington D.C. Photos by Lynn Johnson/Aurora & Quanta.

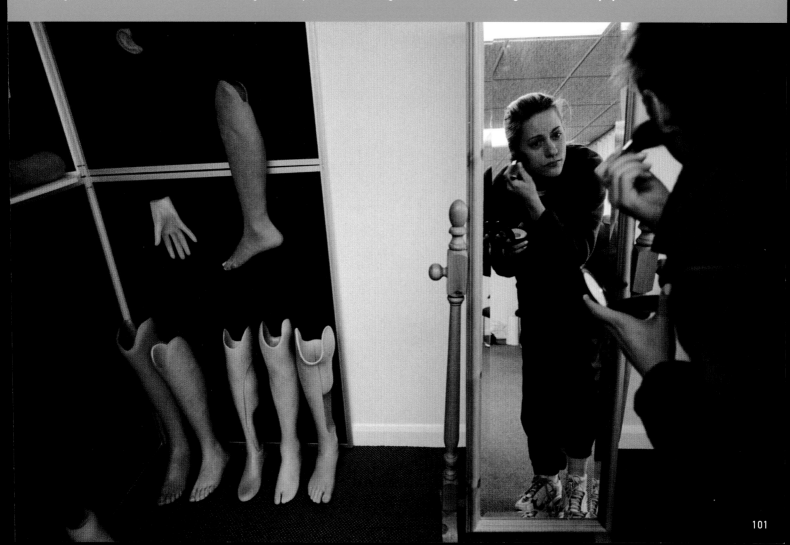

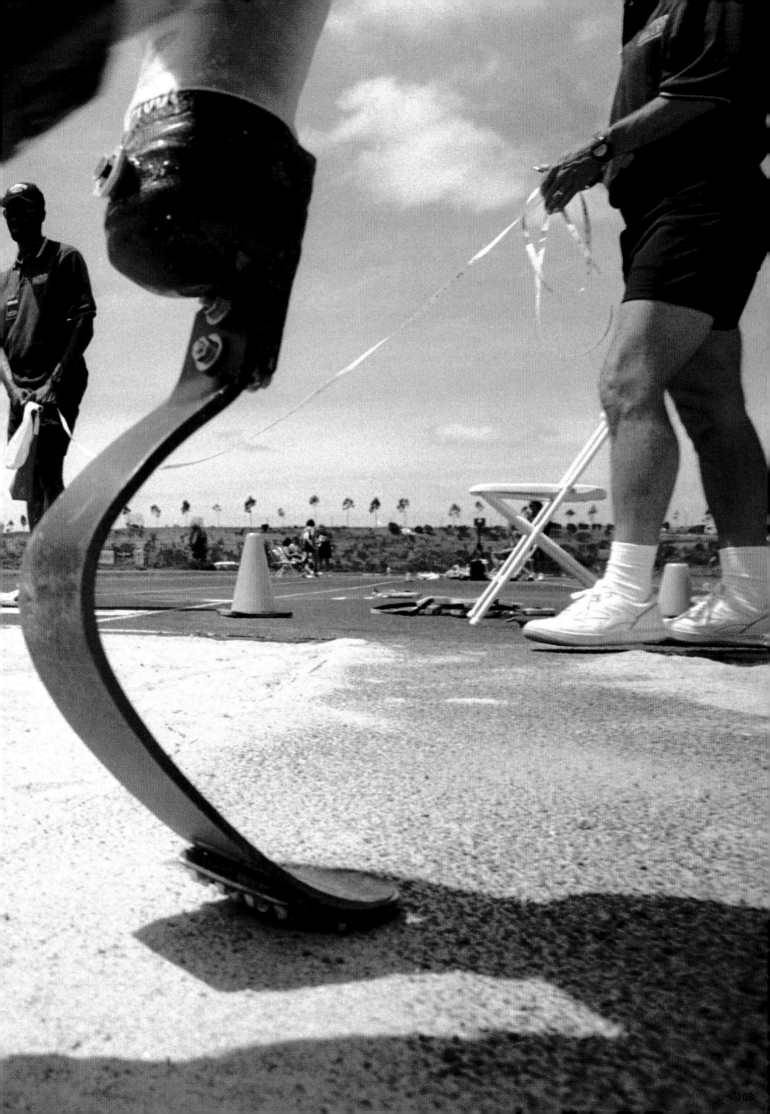

"

My focus during competition is an odd mix of mental awareness and separation. I am conscious of my competitors and surroundings but at the same time, I strive for the "zone," where I can let my body push itself to its maximum potential; a place where I know I am performing at my best without being conscious of the effort. I am typically rather anxious before competition, even when I know I will be the fastest woman. I mostly focus on my breathing, expansion and rhythm, and often visualize the lung expansion and muscle contraction along with a mantra of sorts, that I am strong and speedy and performing at my absolute best. I try very hard not to think about any pain I may be feeling. You can't let it get to you. You can't let yourself get to the point of complaining, of swearing, of excuses, etc.; it's all over then.

MONICA BASCIO (United States)

Highlights: 12nd place at the 1998 National Time Trial (TT) Championship, Duluth, MN; 1st at the 1999 National Criterium Championships, Athens, GA; 1st at the 1999 National TT Championship, Duluth, MN; 1st place in Road Race at 1999 European Disabled Cycling Championships, Bois, France; 1st place in Road Race at the Southern Cross Multi-disability Games, Sydney; Runner-up for 1999 Female Wheelchair Athlete of the Year (Wheelchair Sports USA); 1st, 2000 Lance Armstrong BMC Downtown Criterium, Austin, TX; 2nd Place, 2000 Xcelerate Twilight, Athens, GA; 1st, 2000 Alaska Midnight Sun Stage Race, 1st, 2000 Manhattan Beach Grand Prix, Manhattan Beach, CA; 1st, 2000 National Time Trial Championships, Oswego, NY; 1st, 2000 National Criterium Champ, Binghamton, NY; 1st, 2000 National Road Race Championships, Santa Cruz, CA; 1st, American Handcycle Series, Rocky Mountain National USHF Handcycle Omnium 24 mile Race

Event(s): Handcycling

A friendly match between Bosnia-Herzegovina and Iran, each among the best sitting volleyball teams in the world. The legacy of the wars in Bosnia and

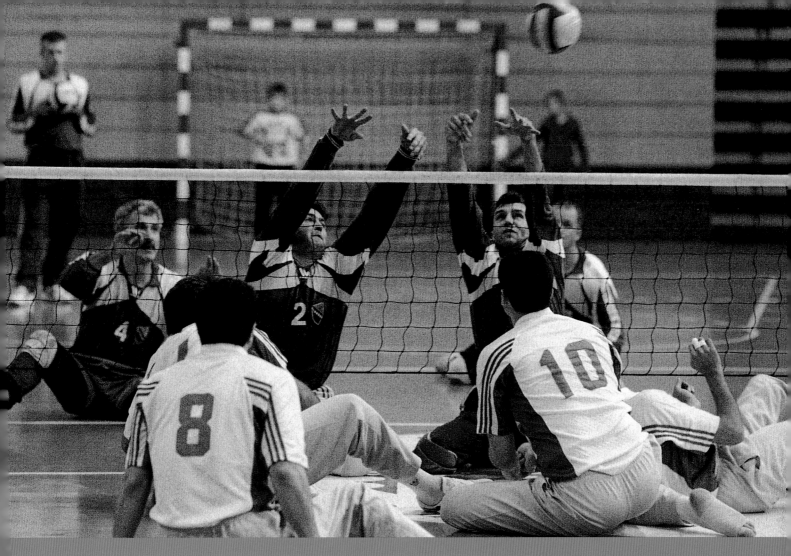

Iran is that thousands of men have lost legs due to mines and other war injuries. Photographs by Paul Lowe.

ALISON PEARL (United States)

Highlights: Gold medals in Super G and Giant Slalom, 2001 US World Cup; Gold medal in Giant Slalom at the 2001 Canadian World Cup.

Event(s): Skiing (Slalom, Giant Slalom, and Super Giant Slalom)

"

I am a twenty-six-year-old athlete. I swim, bike, hike, ski, lift weights—you name it and I will try it. Oh, and by the way, I use crutches and braces to walk. I questioned my own athleticism after I was injured. Athletics played such a large role in my life from the age of three, and what I had known as athletics was taken away from me at the young age of eighteen. Prior to injury I skied, played soccer, ran, roller-bladed, etc. Afterward I was not sure what I would do. It took me one year, post injury, to be re-introduced to sports. As I was slowly introduced to sports, I realized that being an athlete is ME! Whether I am standing and skiing or I am sitting, it is an integral part of me that makes me who I am.

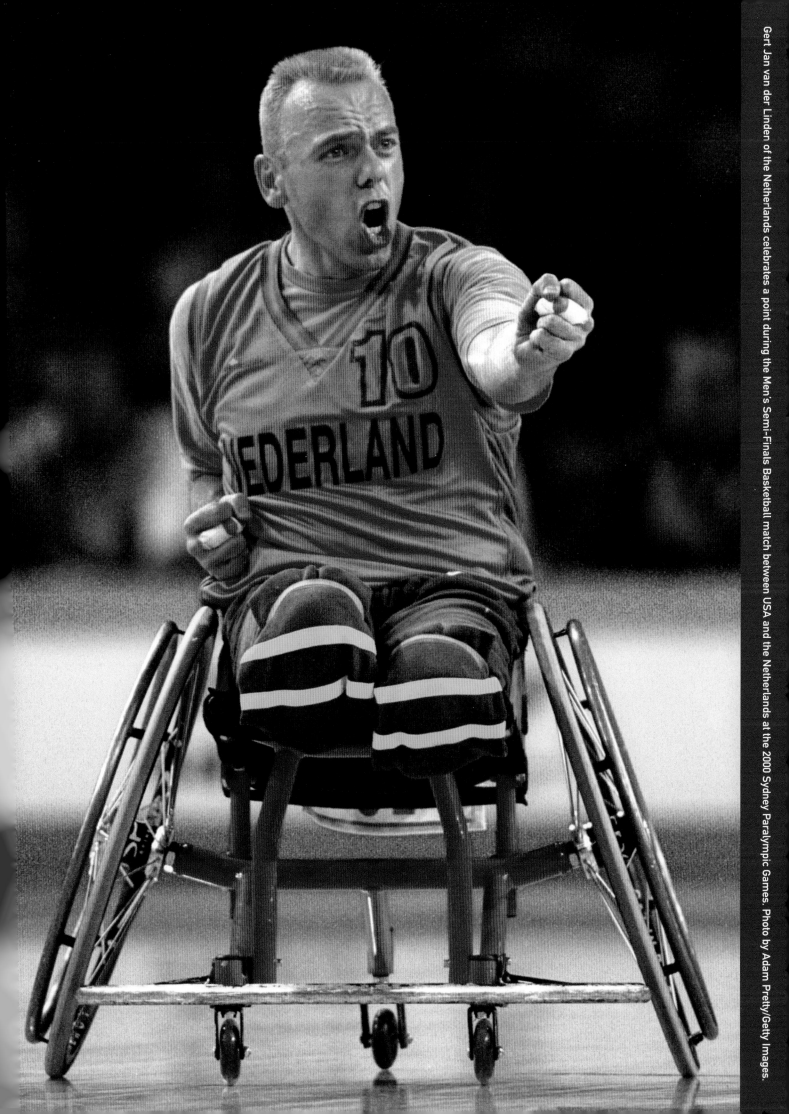

FUNG YING KI (Hong Kong)

Highlights: 3 Gold medals and 1 Bronze, 2000 Sydney Paralympic Games; 2001 Outstanding Athlete of the Year Award from the Hong Kong Sports Association for the Physically Disabled; 2001 Hong Kong Outstanding Athlete Awards from the Sports Federation & Olympic Committee of Hong Kong, China; and a Medal of Honor from the Chief Executive of the Hong Kong Special Administrative Region

Event(s): Fencing (Foil and Sabre)

"

I hope that, in the future, there will no longer be 'disabled athletes' in this world, only 'athletes.' Every athlete should give their best with what they have, and not make excuses for what they might think they are lacking. The way a disabled athlete truly becomes an athlete is by giving their best and pushing themselves to the limit.

Regardless of winning or losing, fair play is essential in our society. All athletes should be able to demonstrate this essential spirit of sport when they are competing: This is the value of athletes in our society.

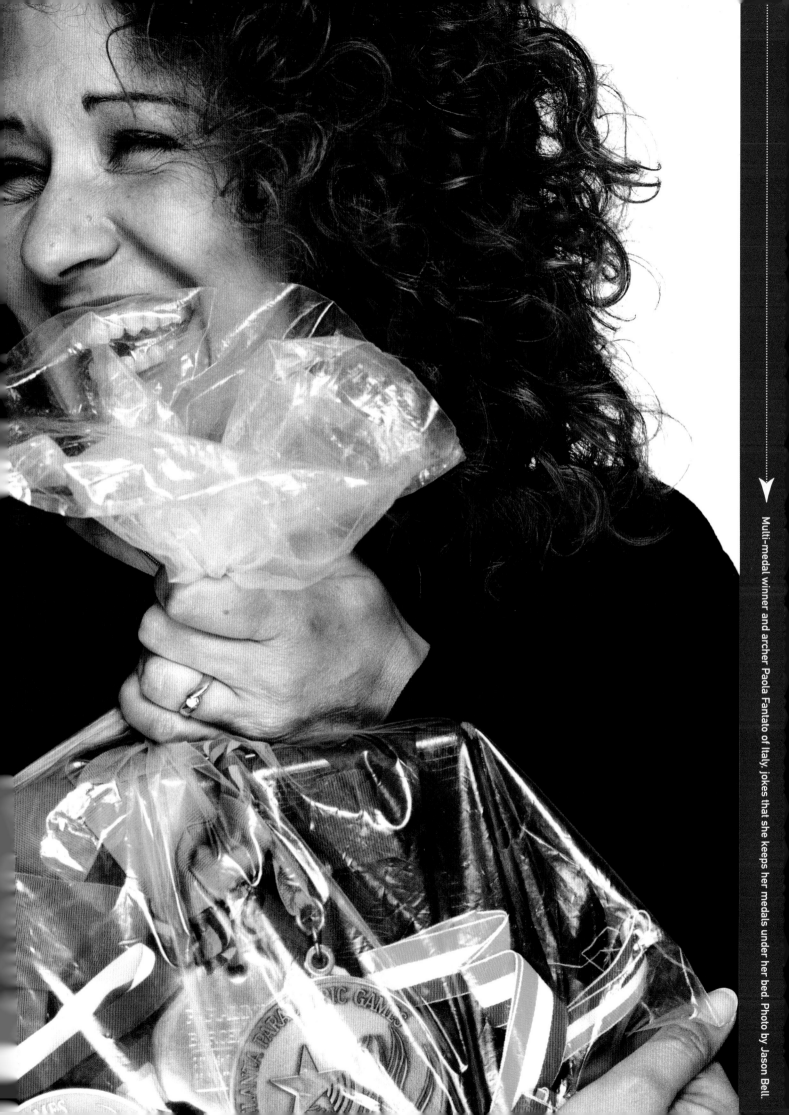

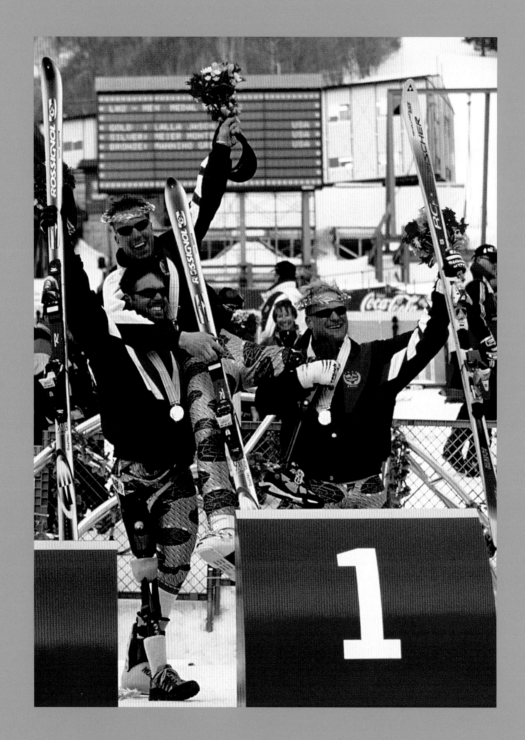

American skiers celebrate sweeping Gold, Silver, and Bronze medals during the 1998 Nagano Paralympic Gamres. Photo by Chris Hamilton.

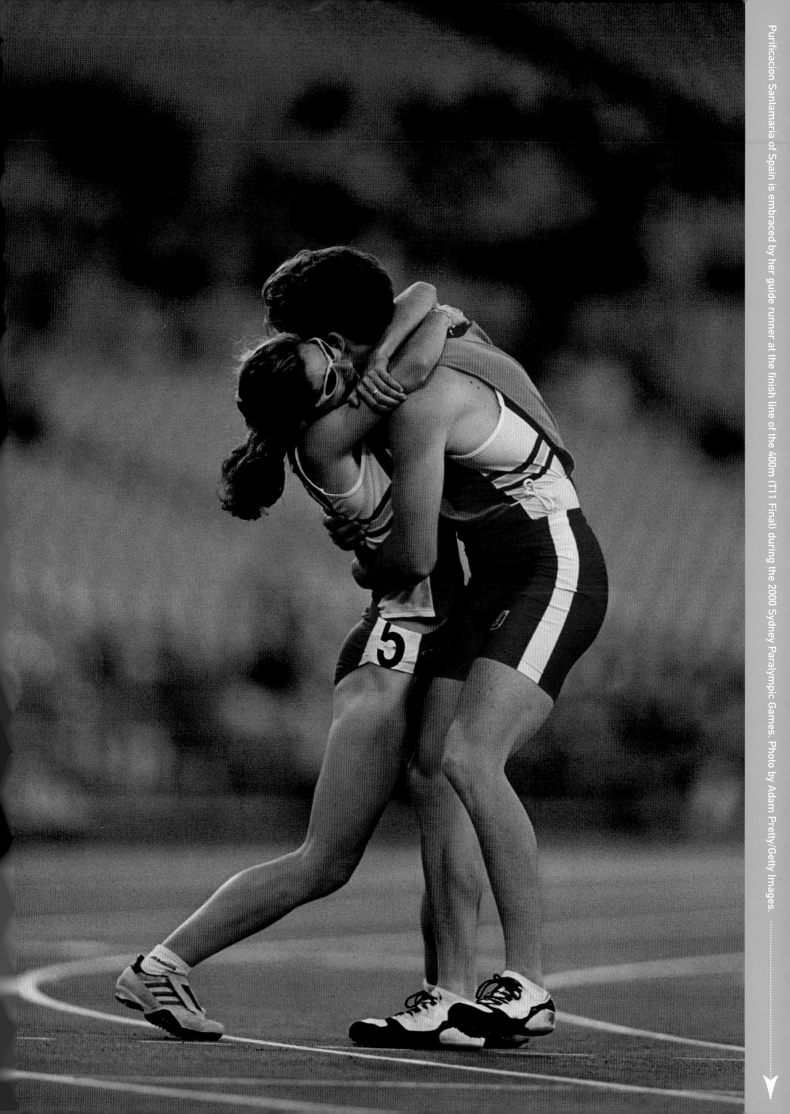

winner

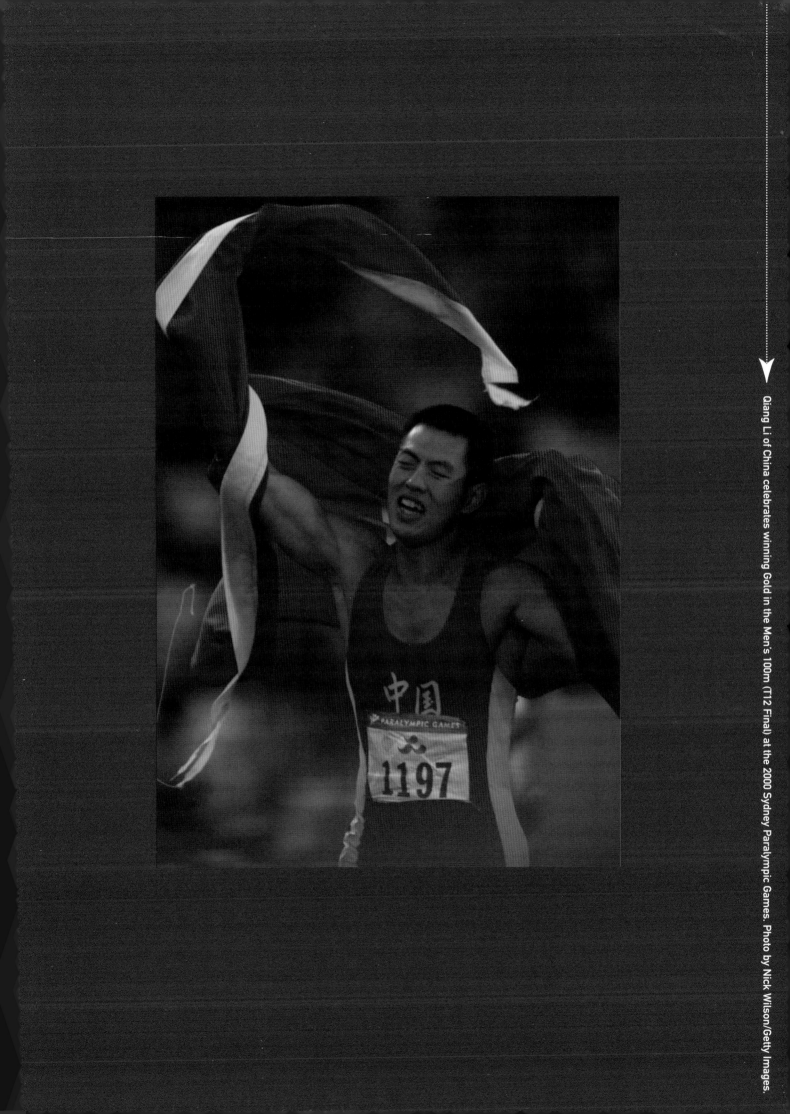

Qiang Li of China celebrates winning Gold in the Men's 100m (T12 Final) at the 2000 Sydney Paralympic Games. Photo by Nick Wilson/Getty Images.

"

Participation in disability sports rebuilds lives. When your life has been turned upside down by a disability, you need successes and you need accomplishments and you need them immediately. Participating in sports rebuilds—it's both a rehab tool and a lifestyle tool available to everyone.

Elite disabled sports is a continuation of that, enabling individuals to achieve the most they can and to perform at the highest level possible—it's more intense, and it's a decision to commit time and energy toward being the very best. That opportunity has to be there also. The accomplishments of the elite athletes provide a quick and easy role model for what is possible. Elite athletics are also a tremendous forum for developing new equipment and technologies to maximize performance.

KIRK BAUER (United States)

Highlight(s): Disabled Vietnam Veteran; Executive Director, Disabled Sports USA; Recipient, 1998 Gene Autry Courage Award.

Event(s): Skiing

ASSISSTIVE TECHNOLOGY AND SPORTS

By Matthew J. Belson

Editor-in-Chief, WeMedia, Inc.

In the realm of sport the desire to go faster, be stronger, and win is universal. No athlete, regardless of his or her ability, wants to be second—rarely are they remembered. It is no surprise that athletes with disabilities are some of the most forceful and creative proponents for many of the advances in prosthetic and mobility enhancing designs.

The last two decades of the twentieth century witnessed an exponential growth in the quality and accessibility of adaptive sporting equipment and prosthetic devices. Gone from the field of competition are the old hospital wheelchairs and "wooden legs." With the introduction of space age materials like carbon fiber and Kevlar, racing chairs became lighter and faster. Running prostheses took on the shape of a cheetah's leg to mimic its explosive energy to help propel a single or double-leg amputee runner down a track. In the twenty-first century, advances in microelectronics and lighter, stronger materials continue to push the limits of design to a point where there may no longer be a distinction between where the person ends and the adaptive device begins.

Yet, enabling technology for athletes with disabilities need not come in high-tech packages costing thousands of dollars. When a blind or vision-impaired runner steps onto a track, it is not the $150 pair of running shoes that allows him or her to compete, but a short piece of twine used as a communication link to their guide runner who matches their strides straight to the finish line. On the water, a few strategically placed pulleys, a line, and a specially modified Captain's chair made from parts found in any hardware

store allow even a sailor with a high level spinal cord injury to sail a 23-foot boat with a crew and even compete against able-bodied sailors. And when a blind skier races down an icy course, it is accomplished only by having complete trust in the guide who skis behind, shouting out commands of when to turn and stop.

To the nascent spectator of disabled sports, the technology used by many athletes can be seductive. The focus is often on the device and not the person. Yes, the sight of a mono-skier tearing up the slopes or a handcyclist achieving a 30-mph sprint can be awe-inspiring, but cutting-edge equipment is not the sole reason for an athlete's achievements. Technology is only as good as the person who uses it and can never replace talent and ability.

Winning the Gold medal or climbing the mountain requires training, dedication, sacrifice, and more training—necessities elite athletes understand and embrace. Technology does not guarantee success, but when meshed with the athlete who understands its limitations as well as its promise, it can help them achieve their dreams. The following spotlights feature a sample of technological advances that have been instrumental in doing just that.

The CB-1 [Freedom Ryder]

WHAT IT IS:

The CB-1 is a handcycle developed from the racebike used by Craig Blanchette, who was the 2000 National Handcycling Criterium Race Champion. The actual bike pictured here is currently being raced by Greg Hockensmith, who received a Silver medal on it in handcycling competitions in Europe. The CB-1 was developed as a race-only model, with a low seating position and extremely responsive handling through body-lean steering. However, it has proven to also be a very capable handcycle for everyday use. Handcycles in general are extremely user-friendly—anyone, disabled and able-bodied alike, can use them, as opposed to racing wheelchairs, which must be custom fitted and usually require training to use effectively. Handcycles are frequently used in long-haul rides, perhaps most famously in the 1995 World T.E.A.M. Sports—sponsored "Ride Around The World," featuring three able-bodied bicyclists on regular bicycles and three disabled handcylists. They cycled through sixteen countries in eight months covering a total of 13,026 miles. However, elite handcycle racing has become more and more visible recently, most prominently with the joining of the USHF (U.S. Handcycling Federation) with the USCF (U.S. Cycling Federation), featuring handcycle races at able-bodied racing events. The CB-1 is part of this increasing popularity, and while it retains the user-friendly nature of an everyday handcycle, it is still true to its roots as a racing handcycle.

HOW IT WORKS:

Like most handcycles currently in production, the CB-1 is a three-wheeled cycle. The frame of the CB-1 consists of two portions: a front portion that consists of the seat, the front wheel, and the hand cranks, and the rear portion, which consists of the back of the frame and the two rear wheels. The two parts of the frame are connected by two pivoting joints. As the cyclist leans his or her body to one side, the front section—seat, front wheel, and crank—tilts with the body in the direction of the lean. The back wheels do not tilt, giving the bike stability and creating an overall smooth turn. Cornering in the CB-1 feels much like carving a turn while snow skiing.

WHAT IS IT MADE OF:

The CB-1 frame is constructed of heat-treated aluminum for strength and lightness, and can be fitted with optional carbon-fiber wheels.

The Flex-Sprint [Flex-Foot]

WHAT IT IS:

The Flex-Sprint, a lower-limb prosthesis, is one key advance in design and technology allowing elite amputee athletes to be on par with able-bodied athletes. Some of the world's fastest amputees use these prostheses—from "World Fastest Amputees" Marlon Shirley and Shea Cowart, to World Record-holders like Neil Fuller. The design of this prosthesis attempts to capture the running characteristics of the hind leg of the fastest land animal, the cheetah, in which the small profile foot extends and reaches out to paw at the ground while the large thigh muscles pull the body forward. Inspired by this, Van Phillips, inventor and founder of the prostheses company, Flex-Foot, introduced a special plantar-flexed toe that allows the runner to land on the forward two inches of the toe, as is customary with able-bodied sprinters, instead of rolling onto the ball of the foot.

HOW IT WORKS:

A small forefoot section in contact with the ground imparts a style of running on the toes without the use or need of a heel segment. A sharply inclined mid-foot diverges away from the ground to focus all ground contact onto the toe. A large, rearward, C-shaped segment distributes the bending energy and provides for vertical movement simulating compliant human joints, effectively reducing impact forces directed back to the limb and body. According to Phillips, himself an amputee, "This angle produces a consistent spring compression rate of the pylon that maximizes its energy storage and release potential." This segment finishes in a fairly vertical segment for mechanical connection to a transtibial socket or prosthetic knee.

WHAT IS IT MADE OF:

The Flex-Sprint is made from 100 percent carbon fiber, a material used extensively in the aerospace industry. This lightweight, advanced carbon composite construction strikes an ideal balance of strength and flexibility, providing structural stability while its unique shape flexes and bends, impersonating foot ligaments and musculature.

The Top End Eliminator OSR [Invacare]

WHAT IT IS:

The Eliminator was used by Louise Sauvage and Franz Nietlispach when they won the Boston Marathon, and Eliminator OSR is the newest in this line of racing wheelchairs that consistently allow athletes to set new world records. The Eliminator, like all racing wheelchairs in production today, is long and low, allowing the athlete to push the wheels as continuously as possible. This hasn't always been the case, however—until 1979, racing chairs were virtually identical to standard chairs, requiring athletes to reach far in order to propel the wheels, and lacking any form of directional mechanism on the front wheels. The Eliminator was developed by Top End, a company started by Chris Peterson and George Murray, the first wheelchair racer to be featured on a Wheaties box.

HOW IT WORKS:

The frame of the Eliminator allows the racer to sit low, offering the least air resistance during a race. Most bikes are made to measure specifically for the racer who uses them, again reducing the area that the bike presents to the air and making the bike as aerodynamic as possible. The precision track compensation system offsets the bike's natural downhill-turning tendency, and allows the bike to remain straight as it heads down the track.

WHAT IS IT MADE OF:

The frame and side panels of the Eliminator are made of aluminum, and the optional wheels are carbon fiber.

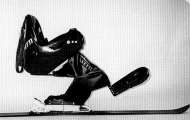

The All Mountain/Race [Yetti]

WHAT IT IS:

One of the oldest competitive disability sports, elite mono-ski racing has existed in the U.S. since 1972, and the mono-ski itself is one of the most demanding pieces of adaptive skiing equipment in terms of strength and skiing technique. The Yetti All Mountain/Race was developed just prior to the Nagano Paralympics in response to requests for higher-performing equipment. Proficient mono-skiers can perform as well or better than able-bodied skiers on the slopes, tackling the most difficult double black diamond terrain. One of the main innovations of the Yetti All Mountain/Race is a shock that has been developed in collaboration with Penske—the first shock to be created exclusively for mono-skis. The Race is designed with conventional bindings to allow mono-skiers smoother and moe complete turns, and to compact the skier's weight as tightly as possible above the "boot center" of the ski so that they can easily place pressure on both the fore and rear sections of the ski to achieve quicker and more precise turns.

HOW IT WORKS:

The diagonal shock and frame design on the All Mountain/Race directs the weight of the skier slightly backwards from the center of the ski during compression to pressure the tail of the ski while using the forward-leaning weight of the skier to control the direction of the mono-ski. The angle and design of the shock also helps the ski stick to the snow as it turns so the skier moves forward smoothly, even as the terrain changes. The conventional ski bindings create a minimal amount of flat space, allowing the ski to flex as it is designed to, minimizing skis' breaking and making near-perfect turns attainable.

WHAT IS IT MADE OF:

The shock towers and seat support system are made from aluminum and chrome moly. The seat and footplate are fiberglass with Kevlar and carbon fiber. The individually made seat is fully padded, and the scat insert and footplate are made of waterproof vinyl. The aerodynamic innovations of the All Mountain/Race, including the frame cover, footplate design, and leg cover, have all been tested in the Chevrolet Wind Tunnel for optimum performance.

resources

UNITED STATES RESOURCES

**American Association of People
with Disabilities**
1819 H Street NW, Suite 330
Washington D.C. 20006
Phone: 800-840-8844; 202-457-0046
Fax: 202-457-0473
E-mail: aapd@aol.com
www.aapd-dc.org

American Association of People with Disabilities (AAPD) is an organization that helps people with disabilities acquire life insurance, receive prescriptions, find careers, and receive help through life planning services. Members pay a small yearly membership fee in exchange for this help. AAPD is a non-profit organization seeking to increase unity, leadership, and impact among the disability community.

Center for an Accessible Society
2980 Beach Street
San Diego, CA 92102
Phone: 619-232-2727
Fax: 619-234-3155
Project Director: Cynthia Jones
E-mail: cjones@accessiblesociety.org
http://www.accessiblesociety.org

The Center for an Accessible Society is a national organization designed to focus public attention on disability and independent living issues by disseminating information developed through the National Institute on Disability and Rehabilitation Research. The National Center for an Accessible Society is a project of Exploding Myths Inc., a media enterprise company.

Center for Disease Control
Public Inquiries/MASO
Mail-stop F07
1600 Clifton Road
Atlanta, GA 30333
Phone: 404-639-3311
http://www.cdc.gov

The Center for Disease Control and Prevention (CDC) is recognized as the leading federal agency for protecting the health and safety of American citizens, providing credible information to enhance health decisions, and promoting health through strong partnerships. CDC serves as the national focus for developing and applying disease prevention and control, environmental health, and promotional and educational activities designed to improve the health of the people of the United States.

USA Deaf Sports Federation
911 Tierra Linda Drive
Frankfort, KY 40601-4633
Phone: 502-573-2604 v/tty;
502-695-2688 v/tty (home)
Fax: 502-695-2783
President: Bobbie Beth Scoggins
E-mail: Scoggins@USADSF.org
http://www.usadsf.org/

The USA Deaf Sports Federation (USADSF) provides year-round training and athletic competition in a variety of sports at the state, regional, national, and international level for developing and elite athletes. Through the United States Olympic Committee's National Governing bodies, the USA Deaf Sports Federation produces competitive United States Teams at the World Games for the Deaf.

**Disabled Businesspersons Association/
Challenged America**
3590 Camino del Rio North
San Diego, CA 92108
E-mail: info@disabledbusiness.com
http://www.disabledbusiness.com

The Disabled Businesspersons Association (DBA) is a charitable organization dedicated to assisting enterprising individuals with disabilities to maximize their potential in the business world. DBA works with vocational rehabilitation, government, and businesses to encourage participation and to enhance the performance of the disabled in the workforce.

Disabled Sports USA
451 Hungerford Drive Suite 100
Rockville, MD 20850
Phone: 301-217-0960; 301-217-9838
(Media Relations)
Fax: 301-217-0968
Executive Director: Kirk Bauer
E-mail: KBauer@dsusa.org
Operations/Program Services Manager:
Kathy Celo
Phone: 724-265-2546
Fax: 724-265-5848
E-mail: KCelo@dsusa.org
http://www.dsusa.org

Disabled Sports USA (DS/USA) offers nationwide sports rehabilitation programs to anyone with a permanent physical disability. Activities include winter skiing, water sports, summer and winter competitions, fitness, and special sports events. Participants include those with visual impairments, amputations, spinal cord injury, dwarfism, multiple sclerosis, head injury, cerebral palsy, and other neuromuscular and orthopedic conditions. Each state has a local chapter branch of DS/USA.

Dwarf Athletic Association of America
418 Willow Way
Lewisville, Texas 75077
Phone: 972-317-8299
Fax: 972-966-0184
Executive Director: Janet Brown
E-mail: daaa@flash.net
http://www.daaa.org

The Dwarf Athletic Association of America (DAAA) was formed in 1985 to develop, promote, and provide quality amateur-level athletic opportunities for dwarf athletes in the United States. DAAA is dedicated to serving the estimated quarter million Americans who are dwarfs (5 feet or less, adult height) as a result of chondrodysplasia or related causes. Clinics, developmental events, and formal competitions are offered at local, regional and national levels.

Eastern Paralyzed Veterans Association
75-20 Astoria Boulevard
Jackson Heights, NY 11370-1177
Phone: 718-803-EPVA (3872)
Fax: 718-803-0414
E-mail: info@epva.org
http://www.epva.org

The Eastern Paralyzed Veterans Association (EPVA) is dedicated to enhancing the lives of veterans with spinal cord injuries or a disease by assuring quality health care, promoting research, and advocating for civil rights and independence. All services, from benefits counseling to wheelchair sports, are supported through greeting-card solicitations and other funding-raising programs. EPVA is a chapter of the congressionally chartered Paralyzed Veterans of America serving New York, New Jersey, Pennsylvania, and Connecticut.

Lakeshore Foundation
4000 Ridgeway Drive
Birmingham, Alabama 35209
Toll free 888.868.2303
www.lakeshore.org

For more than fifteen years, The Lakeshore Foundation has been helping people with physical disabilities explore new avenues. It is a non-profit operating foundation which provides opportunities for people with physical disabilities to live healthy, active lifestyles. Lakeshore has become a national leader in providing opportunities for children and adults with physical disabilities to improve their quality of life, and excel in all aspects of community life including recreation, employment, worship and education.

National Organization on Disability
910 Sixteenth Street, N.W.
Suite 600
Washington D.C. 20006
www.nod.org

The National Organization on Disability (NOD) funds programs to help the disability community with everyday struggles such as employment, education, transportation, health care, and technology. The NOD promotes the full and equal participation of all America's disabled in all aspects of life. NOD is the only national disability network organization concerned with all disabilities, all age groups, and all disability issues.

National Parent Network on Disabilities
1130 17th street N.W.
Suite 400
Washington D.C. 20036
Phone: 202-463-2299
Fax: 202-463-9405
E-mail: npnd@mindspring.com
http://www.npnd.org

The National Parent Network on Disabilities (NPND) is a nonprofit organization dedicated to empowering parents and ensuring that parents and families of children, youth, and adults with a disability have a voice in policy decisions at the national level. NPND provides its members with the most up-to-date information on the activities of all three branches of the government that impact individuals with disabilities and their families.

National Sports Center for the Disabled
P.O. Box 1290
Winter Park, CO 80482
Phone: 970-726-1540; 303-316-1540
Fax: 970-726-4112
Denver Office:
633 17th Street, #24
Denver, CO 80202
Phone: 303-293-5711
Fax: 303-293-5448
E-mail: info@nscd.org
http://www.nscd.org

For almost thirty-five years, the National Sports Center for the Disabled (NSCD) has been providing recreation opportunities for children and adults with disabilities. It is one of the largest and most successful programs of its kind in the world. In addition to recreational downhill and cross-country skiing, snowboarding, and snowshoeing lessons, NSCD provides year-round competition training to ski racers with disabilities.

Paralyzed Veterans of America
801 Eighteenth Street, NW
Washington D.C. 20006-3517
Phone: 800-424-8200
E-mail: info@pva.org
http://www.pva.org

The Paralyzed Veterans of America (PVA), a congressionally chartered veterans' service organization, has developed a unique expertise on a wide variety of issues involving the special needs of its members. PVA uses that expertise to be the leading advocate for: quality health care for members, research and education addressing spinal cord injury and dysfunction, benefits available as a result of members' military service and civil rights, and opportunities which maximize the independence of its members.

Rehabilitation Institute of Chicago
Helen M. Galvin Center for Health and Fitness
710 N. Lake Shore Drive
Chicago, IL 60611
(312) 908-4292
http://www.rehabchicago.org/

The Rehabilitation Institute of Chicago's (RIC) Center for Health and Fitness was specifically created to provide an arena for individuals to develop their physical potential. From routine exercise programs to competitive opportunities, individuals of all ages, backgrounds and levels of ability can be seen working out together at any given time. RIC's Center for Health and Fitness also offers a referral program on adapted sports and recreation equipment as well as other established programs and services throughout the United States.

U.S. Association of Blind Athletes
33 N. Institute St.
Colorado Springs, CO 80903
Phone: 719-630-0422
Fax: 719-630-0616
http://www.USABA.org

The United States Association of Blind Athletes (USABA) seeks to change the attitudes about the abilities of the blind and visually impaired. A world-class trainer of 3,000 blind and visually impaired athletes, USABA reaches into hundreds of communities across the United States, helping thousands of blind and disabled youth discover their own potential in school and sports, and in the achievement of their own personal dreams. USABA trains athletes in Alpine and Nordic skiing, goalball, judo, powerlifting, swimming, tandem cycling, track and field, and wrestling.

U.S. Paralympics
25 N. Tejon, Lower Level 110
Colorado Springs, CO
80909-5760
United States
Phone +1 (719) 471-8772
Fax +1 (719) 471-0196
http://www.olympic-usa.org

The U.S. Paralympics, is a division of the U.S. Olympic Committee, focused on enhancing programs and revenues for elite Paralympic athletes. U.S. Paralympics provides more than $3 million annually to support elite Paralympic athletes. The U.S. Paralympics also collaborates with state and local organizatipons to promote excellence in the lives of persons with disabilities.

Wheelchair Sports, USA
3595 E. Fountain Blvd, Suite L-I
Colorado Springs, CO 80910
Phone: 719-574-1150
Fax: 719-574-9840
E-mail wsusa@aol.com
http://www.wsusa.org

Wheelchair Sports, USA (WSUSA) is an organization that helps athletes with disabilities to practice sports from Wheelchair basketball and rugby to Wheelchair fencing. WSUSA was originally formed to help veterans of World War II, but eventually expanded to include women, quadriplegics, and junior athletes. WSUSA helps athletes to prepare for the Paralympics and works to increase public awareness of wheelchair athletic competition.

INTERNATIONAL RESOURCES

Cerebral Palsy—International Sports and Recreation Association (CP-ISRA)
Mrs. Margret Kellner
P.O. Box 16
6666 ZG Heteren
Netherlands
Telephone: +31 2647 22593
Fax: +31 2647 23914
E-mail: cpisra_nl@hotmail.com
http://www.cpisra.org

Cerebral Palsy-International Sports and Recreation Association (CP-ISRA) coordinates, promotes, and fosters sports for people with cerebral palsy and related neurological conditions. CP-ISRA plans, coordinates, and organizes competitions and sporting events at Regional, Continental, and World levels. The association also works to encourage and aid

countries to develop sports projects and competitive sporting activities for people with disabilities.

Disabled Peoples' International
DPI Europe Regional Development Office
11 Belgrave Road
London SW1V 1RB
UK
Managing Editor: Susan Morgan
E-mail: smorgan@icenter.net
New York Office:
Executive Director of Headquarters: Lucy Wong-Hernandez
E-mail: lucywdpiny@aol.com
http://www.dpi.org

The purpose of Disabled Peoples' International (DPI) is to promote the Human Rights of People with Disabilities through full participation, equalization of opportunity, and development. The main functions of DPI are Development, Human Rights, Communications, Advocacy, and Public Education. DPI continually works to develop partnership and linkages with government, business, and the academic world wherever they might be mutually beneficial.

English Federation of Disability Sport
Manchester Metropolitan University
Alsager Campus, Hassall Road
Alsager Stoke-on-Trent ST7 2HL
UK
Phone: 0161-247-5294
Fax: 0161-247-6895
Minicom: 0161-247-5644
E-mail: federation@efds.co.uk
http://www.efds.co.uk

The English Federation of Disability Sports is responsible for developing sports for disabled people in England. They aim to expand sporting opportunities for disabled people and actively increase the number of disabled people involved in sport by helping and encouraging sports providers to include sporting opportunities for disabled people.

La Fédération Internationale de Nation (FINA)
Av. De l'Avant-Poste 4
1005 Lausanne
SWITZERLAND
Phone: 41-21 310 4710
Fax: 41-21 312 6610
http://www.fina.org

La Fédération Internationale de Nation (FINA) focuses on swimming, water polo, diving, synchronized swimming, and open water swimming for the disabled. FINA

prepares its athletes to perform in a variety of aquatic competitions.

Hong Kong Sports Association for the Physically Disabled
Unit 141-148, G/F.
Block B, Mei Fung House,
Mei Lam Estate,
Shatin, N.T.
HONG KONG
http://www.hksap.org

HKSAP promotes and encourages sports activities among the physically disabled, and organizes different sports activities and sports training. They are also responsible for selecting athletes and organizing the Hong Kong Teams for all international competitions.

International Athletic Foundation
Stade Louis II
Avenue Prince Héréditaire Albert
MC 98000
MONACO
Phone: 377 92 05 70 68
Fax: 377 92 05 70 69.
http://www.iaaf.org

The International Athletic Foundation's mission is to charitably assist the world governing body for track and field athletics in perpetuating the development and promotion of athletics worldwide. Through its support of a variety of programs and projects, the Foundation strives to aid athletes, administrators, coaches, national athletics federations, and others to practice all forms of athletics in the best of conditions. The Foundation's projects include educational courses, seminars, and conferences to promote a better knowledge of the sport of athletics.

International Blind Sports Association (IBSA)
Mr. Enrique Sanz
c/ Quevedo 1
28014 Madrid
Spain
Telephone: +34 91 589 4533
Fax: +34 91 589 4537
E-mail: ibsa@ibsa.es
http://www.ibsa.es

The International Blind Sports Association (IBSA) seeks to open an international communications channel allowing everyone to see the sporting capabilities, at all levels, of blind and visually impaired people. Competition sport is the spearhead by means of which IBSA aims to promote the full potential of these persons who, deprived

of vision or with serious visual impairments, strive to achieve acceptance, both in the labor market and within society in general.

International Center for Disability Resources on the Internet (ICDRI)
8105 Brumbley Place
Raleigh, NC 27612
Phone: 919-349-6661
E-mail: icdri@icdri.org or
9193496661@mobile.att.net
http://www.icdri.org

The International Center for Disability Resources on the Internet (ICDRI) collects and presents the best practices in areas related to disability and accessibility issues. They collect disability-related Internet resources, including resources that may be helpful to the disability community and present them in a manner that is accessible to the widest user audience. ICDRI develops and makes available the techniques used to make these presentations, and assists those who wish to use their methods.

International Committee of Sports for the Deaf (CISS)
814 Thayer Avenue
Suite #350
Silver Spring, MD 20910
Fax: 301-650-6595
E-mail: info@ciss.org
http://www.ciss.org

The Comité International des Sports des Sourds (CISS) aims to celebrate the spirit of Deaf Sports. CISS is a place where Deaf athletes come together as members of a cultural and linguistic minority to strive to reach the pinnacle of competition, with the motto: PER LUDOS AEQUALITIAS (Equal Through Sports). They develop new training programs and expand existing opportunities for Deaf people to participate in sports at international standards, and award, supervise, and assist in the coordination of the Deaf World Games.

International Sports Federation for Persons with Intellectual Disability (INAS-FID)
Jos Mulder
President and acting Secretary General
Munnikenpark 9
2351 CL Leiderdorp
The Netherlands
Telephone: +31 71 5892293
Fax: +31 71 5895882
E-mail: jos.jopie.mulder@freeler.nl

INAS-FID believes that persons with intellectual disability have the right to partici-

pate in the sport of their choice at the level of ability they desire. This may be in banded competition as organized by SOI (Special Olympics International), or in open competition as promoted by INAS-FID. INAS-FID regularly organizes conferences and seminars with the aim to enhance sport for persons with intellectual disability.

International Paralympic Committee
Adenauerallee 212-214
53113 Bonn
GERMANY
http://www.paralympic.org
The International Paralympic Committee (IPC) is the international representative organization of elite sports for athletes with disabilities. IPC organizes, supervises, and co-ordinates the Paralympic Games and other multi-disability competitions. It is a non-profit organization formed and run by 160 National Paralympic Committees.

International Stoke Mandeville Wheelchair Sports Federation (ISMWSF)
Ms. Maura Strange
Olympic Village
Barnard Crescent
Aylesbury
Buckinghamshire HP2
United Kingdom
Telephone: +44 1296 436179
Fax: +44 1296 436484
E-mail: maura.strange@wsw.org.uk
The International Stoke Mandeville Wheelchair Sports Federation provides services to over seventy member nations and functions as wheelchair sports' international governing body. The funding and marketing division of the ISMWSF is the Wheelchair Sports Worldwide Foundation.

International Sports Organization for the Disabled (ISOD)
Mr. Alan Dean
16 Mosaics Avenue
Aurora
Ontario L4G 7L5
Canada
Telephone: +1 905 726 9501
Fax: +1 905 726 9501
E-mail: dean.alan@ic.gc.ca
The International Sports Organization for the Disabled was created to foster international cooperation between the national organizations of sports for the disabled. Its purpose is: 1) To provide an international forum for the exchange of opinion, 2) To prepare and disseminate international prin-

ciples and standards for application to all programs of sports for the disabled, 3) To plan and promote international events and activities designed to stimulate and assist the further development of said programs in all nations.

Olympics National Headquarters
One Olympic Plaza
Colorado Springs, CO 80909
Phone: 412-621-6511
Fax: 412-621-6512
http://www.olympic.org
The International Olympic Committee (IOC) is an international, non-governmental, non-profit organization and the creator of the Olympic Movement. The IOC exists to serve as an umbrella organization of the Olympic Movement, including the Paralympics. Its primary responsibility is to supervise the organization of the summer and winter Games. The main purpose of the IOC and the Olympic Movement is to contribute to building a peaceful and better world by educating youth through sport practiced without discrimination of any kind and in the Olympic Spirit.

World Association of Persons with disAbilities
4503 Sunnyview Dr., Suite 1121
Post Office Box 14111
Oklahoma City, Oklahoma 73113
Phone: 405-672-4440
Fax: 405-672-4441
http://www.wapd.org
World Association of Persons with

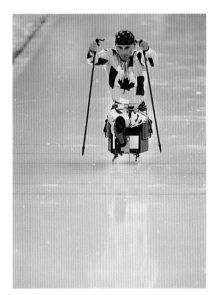

H. Lord of Canada competes in Sledge Speed Skating at the 1994 Lillehammer Paralympic Games. Photo by Clive Brunskill/Getty Images.

disAbilities (WAPD) advances the interests of people with disabilities at national, state, local, and home levels. WAPD focuses on improving issues affecting people with disabilities such as: insurance, employment, disability equipment, working at home, and telephone systems.

MEDIA RESOURCES

Challenge Magazine
Disabled Sports USA
451 Hungerford Drive
Suite 100
Rockville, MD 20850
Phone: 301-217-0960
Fax: 301-217-0968
http://www.dsusa.org/challengemag.htm
Published three times a year by Disabled Sports USA, Challenge Magazine features the latest news on parathletics and paralympics. They cover all sporting events.

Paraplegia News
2111 East Highland Avenue
Suite 180
Phoenix, AZ 85016
Phone: 888-888-2201
www.pn-magazine.com
Paraplegia News (PN) is now in its 55th year of publication. It is an official organ of the Paralyzed Veterans of America, dedicated to the presentation of all news concerning spinal-cord-injured/disabled civilians and veterans, as well as news on wheelchair living.

Sports 'n Spokes
Phone: 888-888-2201
http://www.sns-magazine.com
Sports'n Spokes is published by the Paralyzed Veterans of America. It is the only magazine with international circulation, covering the latest in competitive wheelchair sports and recreational opportunities.

WeMedia Inc.
130 William Street
New York, NY 10038
Phone: 646-769-2722
Fax: 212-375-6266
Email: editorial@wemedia.com
www.wemedia.com
WeMedia Inc. covers issues important to the millions of people with disabilities interested in a quality life without compromise. WeMedia is committed to providing increased access to information, products, and services to people with disabilities,

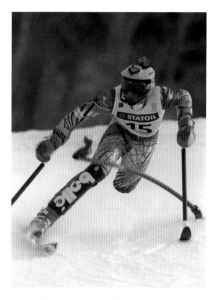

Sarah Billmeier of the USA rounds the poles of the Women's Slalom course at the 1994 Lillehamer Paralympic Games. Photo by Clive Brunskill/Getty Images.

their families and friends. WE Magazine is a glossy consumer lifestyle publication and is now available on audiotape for persons who are blind or have low vision. www.wemedia.com is a comprehensive online resource providing targeted information, products, and services.

EDUCATIONAL RESOURCES

Amputee Website
http://www.amputee-online.com
Hosted at SJU, the Disability Sport Listserv serves as a medium of communication between athletes, coaches, administrators, academics, media, and other interested parties. Subject matter has included: inclusion of athletes in non-disabled events, results from around the world, publication releases, the Paralympics, equipment, and dealing with the media.

Canadian Center on Disability Studies
56 The Promenade
Winnipeg, Manitoba
CANADA R3B 3H9
Phone: 204-287-8411
http://www.escape.ca/~ccds
CCDS is a consumer-directed university-affiliated center dedicated to research, education, and information dissemination on disability issues. The Canadian Center on Disability Studies conducts research that promotes the full and equal participation of people with disabilities in all aspects of society. CCDS supports the work of community-based disability groups and researchers by providing small research grants, ethical review process, and research skills training.

Center for the Study for Sport in Society
Northeastern University
360 Huntington Avenue, Suite 161 CP
Boston, MA 02115-5000
Phone: 617-373-4025
Fax: 617-373-4566
E-mail: sportinsociety@hotmail.com
http://www.sportinsociety.org
The Northeastern University's Center for the Study of Sport in Society (SIS) increases awareness of sport and its relation to society, and develops programs that identify problems, offer solutions, and promote the benefits of sport. SIS oversees educational and outreach programs that teach young people about social issues and that inspire them to play positive roles in society through the use of sports.

Disability Resource Center
University of Arizona
1540 E. 2nd Street
Tucson, AZ 85721
Email: drc@w3.arizona.edu
http://drc.arizona.edu
The Disability Resource Center works to structure and deliver services in ways that promote individual growth, and increase access and opportunities for people with disabilities through collaboration. The Center promotes a broad definition of diversity that honors and appreciates disability as an integral part of human experience. The Disability Resource Center provides a comprehensive program of competitive athletics and recreational activities to ensure equal access for students with disabilities.

Lemelson Assistive Technology Development Center
Hampshire College-LM
893 West Street
Amherst, MA 01002
LATDC Contact: Lauren Way,
E-mail: lway@hampshire.edu
http://lemelson.hampshire.edu
The Lemelson Assistive Technology Development Center (LATDC) provides students with an experiential education in applied design, invention, and entrepreneurship through the use of assistive technology and universal design. Teams of students design, develop, and make equipment available for people with disabilities. Students of all levels can get involved at LATDC by taking a course, fulfilling a community service requirement, learning computer-aided drafting, completing a divisional project, joining a team working on a prototype, or designing something of their own.

National Center on Physical Activity and Disability
1640 W. Roosevelt Road
Chicago, IL 60608-6904
Phone: 800-900-8086
Fax: 312-355-4058
http://ncpad.cc.uic.edu
The National Center on Physical Activity and Disability (NCPAD) believes that exercise is for everybody, and everyone can reap benefits from regular physical activity. NCPAD is operated by the Department of Disability and Human Development at the University of Illinois in Chicago. Their goal is to encourage and support people with disabilities who wish to increase their overall level of activity and participate in some form of regular physical activity.

The Steadward Centre for Personal & Physical Achievement
W1-67 Van Vliet Centre
University of Alberta
Edmonton, Alberta
Canada T6G 2H9
Phone: 780-492-3182
Fax: 780-492-7161
E-mail: info@steadwardcentre.org
http://www.steadwardcentre.org/
The Steadward Centre provides fitness and lifestyle programs, instruction and research for people with physical disabilities. The Centre is one of the research centres and units in the University of Alberta's Faculty of Physical Education and Recreation.

USA Disabled Athletes Fund, Inc.
1775 The Exchange, Suite 540
Atlanta, Georgia 30339
770-850-8199
Email:info@blazesports.com
The USA Disabled Athletes Fund (US DAF) is dedicated to advancing the disability sport movement as a means of improving the quality of life and economic independence of disability athletes. US DAF also works to enhance the quality of coaching and professional development, and to improve and expand the network of available recreation and sport opportunities at school and community levels.

A venture capitalist, executive coach, and para-athlete currently training for the National Championships in table tennis, Artemis A. W. Joukowsky III has been active in the disability community for a number of years. He serves as a board member of the Families of Spinal Muscular Atrophy, the leading service provider and researcher to find a cure for the illness he shares with others throughout the world. He also serves on the board of Partners for Youth with Disabilities and is the Chairman and cofounder of No-Limits Media, a non-profit organization whose goal is the development of innovative media projects for people with disabilities. Joukowsky is a founding member of the Board of Advisors for the Lemelson Assistive Technology Development Center at Hampshire College, an academic program that supports student invention and design of adaptive equipment. His life-long participation in disabled sports and recreation activities and continuing passion to support other disabled athletes has led directly to him playing the role as Executive Producer of this book and cowriter of the essay with Larry Rothstein. In addition to his work in the disability community, Joukowsky is a cofounder of a venture capital fund, on the Board of five private companies and six non-profit organizations. Joukowsky lives with his wife Peg and three girls in Sherborn, Massachusetts.

Christopher Reeve is internationally celebrated as an actor, director, and activist. From his first appearance at the Williamstown Theatre Festival at the age of fifteen, to his studies at Cornell University and Juilliard and subsequent appearances on stage and film, Reeve established a reputation as one of the country's leading actors. Since being paralyzed in an equestrian competition in 1995, Reeve has not only put a human face on spinal cord injury but he has motivated neuroscientists around the world to conquer the most complex diseases of the brain and central nervous system. In 1999, Reeve became the Chairman of the Board of the Christopher Reeve Paralysis Foundation (CRPF). CRPF, a national, nonprofit organization, supports research to develop effective treatments and a cure for paralysis caused by spinal cord injury and other central nervous system disorders. CRPF also allocates a portion of its resources to grants that improve the quality of life for people with disabilities. As Vice Chairman of the National Organization on Disability (NOD), he works on quality of life issues for the disabled. In partnership with Senator Jim Jeffords of Vermont, he helped pass the 1999 Work Incentives Improvement Act, which allows people with disabilities to return to work and still receive disability benefits. Reeve is on the Board of Directors of World T.E.A.M. Sports, of TechHealth, (a private company that assists in the relationship between patients and their insurance companies) and of LIFE (Leaders in Furthering Education), a charitable organization that supports education and opportunities for the underserved population.

Larry Rothstein is a writer and collaborator who has co-authored the national best sellers *Minding the Body, Mending the Mind, You Are Not Alone,* and *You Are What You Say.* He has also served as an editor of the *Harvard Business Review* and the *Harvard Educational Review.* Before entering writing full time, he served in government at both the state and federal levels. He holds a doctorate from Harvard in public policy analysis, and maintains an interest in the field of civil rights, particularly as it applies to people with disabilities. He is also cofounder with Artemis Joukowsky and Dan Jones of No-Limits Media.